SAN FRANCISCO

The Cool, Gray City of Love

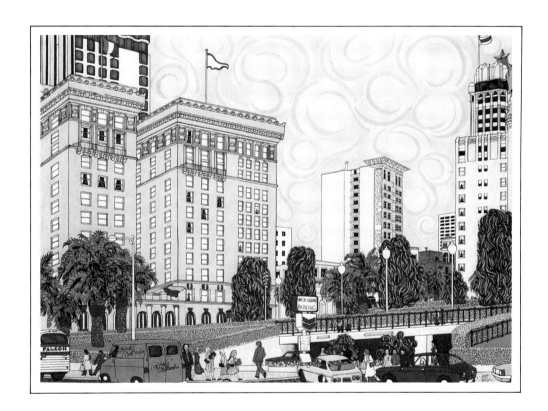

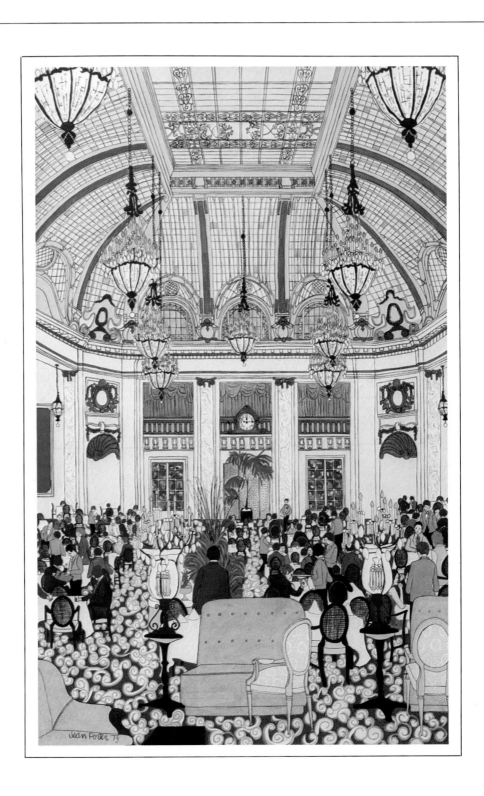

SAN FRANCISCO

The Cool, Gray City of Love

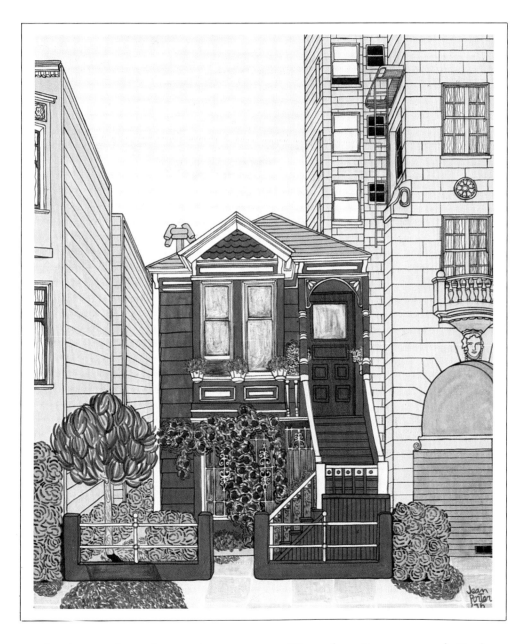

Paintings by Jean Porter Text by Leonard Cahn

E. P. DUTTON / NEW YORK

JEAN PORTER was born in California. She has painted from earliest childhood here and in Spain, Italy, and England. Her admiration for the performing arts has led her to help in the presentation of many renowned artists and groups, such as Artur Rubinstein, the American Ballet Theatre, and Bunraku from Japan. In San Francisco, as the first manager for the Palace of Fine Arts Theatre, she turned it into one of the most active theatres for dance and musical performances. While there, she conceived and produced the highly successful Summerdance series. She has also worked for a documentary film company as production manager. Since 1975 Miss Porter has devoted herself entirely to painting. Her works are in many private collections in the United States and Great Britain and have been added to several corporate collections including Amfac Corporation, Macy's, and The Bank of California. Miss Porter is currently living and working in San Francisco. She plans to travel to Paris, London, and New York to paint the theatrical scenes she knows so well.

LEONARD CAHN is a writer, planner, designer, and successful land developer. He arrived in San Francisco some forty years ago off a coastwise tanker. He went to Spain to fight with the Lincoln Brigade, then returned to spend several years working on the waterfront. The homes he has designed and built have been the subject of architectural tours. He has written short stories, plays, and poetry. Most recently, his version of Igor Stravinsky's *L'Histoire du soldat* and a new construction of Oscar Wilde's *The Picture of Dorian Gray* set to music and with dance have been produced by the Xoregos Performing Company. At present Mr. Cahn is working on a novel that concerns itself with the development of a large real estate project on the San Francisco waterfront.

First published, 1981,
in the United States by E.P. Dutton,
a division of Elsevier-Dutton Publishing Co., Inc.,
2 Park Avenue, New York, N.Y. 10016

Library of Congress Catalog Card Number: 80-65358
ISBN: 0-525-93180-5 (cloth)
ISBN: 0-525-47663-6 (DP)

Published simultaneously in Canada by
Clarke, Irwin & Company, Limited, Toronto and Vancouver

Design: Nicola Mazzella

10 9 8 7 6 5 4 3 2 1

First Edition

Printed and bound by
South China Printing Co., Hong Kong.

to Shela Xoregos

THE COOL, GRAY CITY OF LOVE
THE CITY OF SAINT FRANCIS

Tho I die on a distant strand,
 And they give me a grave in that land,
Yet carry me back to my own city!
Carry me back to her grace and pity!
 For I think I could not rest
 Afar from her mighty breast.
 She is fairer than others are
 Whom they sing the beauty of.
 Her heart is a song and a star—
 My cool, gray city of love.

 Tho they tear the rose from her brow,
 To her is ever my vow;
Ever to her I give my duty—
First in rapture and first in beauty,
 Wayward, passionate, brave,
 Glad of the life God gave.
 The sea-winds are her kiss,
 And the sea-gull is her dove;
 Cleanly and strong she is—
 My cool, gray city of love.

 The winds of the future wait
 At the iron walls of her Gate,
And the western ocean breaks in thunder,
And the western stars go slowly under,
 And her gaze is ever West
 In the dream of her young unrest.
 Her sea is a voice that calls,
 And her star a voice above,
 And her wind a voice on her walls—
 My cool, gray city of love.

 Tho they stay her feet at the dance,
 In her is the far romance.
Under the rain of winter falling,
Vine and rose will await recalling.
 Tho the dark be cold and blind,
 Yet her sea-fog's touch is kind,
 And her mightier caress
 Is joy and the pain thereof;
 And great is thy tenderness,
 O cool, gray city of love!

 —*George Sterling,* unofficial poet
 laureate of San Francisco

CONTENTS

ACKNOWLEDGMENTS

Miss Porter and Mr. Cahn wish to express their gratitude to the following for their help in this book.

Michael Larsen and Elizabeth Pomada for their valued assistance; Cyril I. Nelson, our editor at Dutton, for his expert guidance; Captain David H. Saunders for his valuable insight into the early port development; Sharon Vera-Berry for her aid in editing; Philly Joe Jones at the Keystone Korner, Donald Pippin and his Pocket Opera Company, and Khrista Bennion, Jennifer Kope, Ah Ling Neu, and Robert Rinehart of the Ridge Quartet for their willingness to allow Miss Porter to paint during rehearsals; Pat Dement and Tom Miller of the City of San Francisco, Jim Kerber of the American Conservatory Theatre, Russell Hartley and Judith Solomon of the San Francisco Archives for the Performing Arts, Nancy Steele and Jo Ann Driscoll of the San Francisco Ballet, Jay A. Darwin and William Howe, Jr., of the San Francisco Chamber Music Society, Marilyn Mercur and Richard Stead of the San Francisco Opera, Nancy Carter of the San Francisco Symphony, and Philip Elwood, jazz critic for the *San Francisco Examiner*. In San Francisco, the many staff members of the California Historical Society: Schubert Library, Chinese Historical Society of America, Mechanics' Institute Library, San Francisco Public Library: San Francisco Room and Archives/Chinatown Branch, Society of California Pioneers Library; Menlo Park Public Library, Menlo Park, California; Redwood City Public Library, Redwood City, California; and the Stanford University Libraries, Stanford, California; Robert Messick, photographer; Thomas Moulin of the Gabriel Moulin Studios for his careful handling of the original paintings while photographing them; Elede Toppy Hall for her painstaking research into the history of San Francisco, her contribution was invaluable.

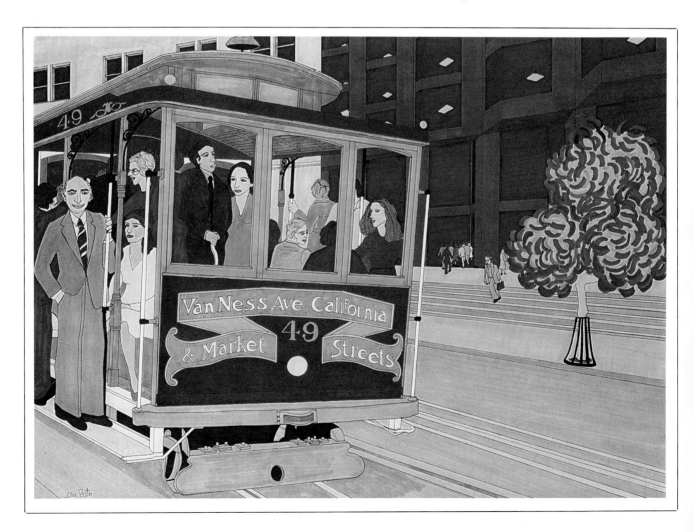

INTRODUCTION

George Sterling had a cool and gray impression of San Francisco expressed in his poem. When I hear the foghorns at night, I know the city will more often than not be brilliant by late morning. The white, pale yellows, and other light colors will look hot. The lines of buildings, the verdure, the bay, and the ocean will be wonderfully clear and sharp. These impressions are expressed in my paintings.

The colors of San Francisco are quite different from one part of the city to the next. Chinatown is as bright inside its buildings as outside. There seems to be less air, more congestion, and constant activity. Yellow, orange, red, blue, green, violet, and vermilion are used straight from the tube. The financial district and the downtown area adjoining Chinatown have a more subdued feeling. The waterfront, from the Embarcadero to the Pacific Ocean, changes from cerulean blue to cobalt blue. Pier 28, under the Bay Bridge, was painted on a cold, overcast day that brought out the brilliance of violet, red, and yellow with the cerulean blue. The Pacific Ocean smashing against the steps at the Great Highway was painted just before a storm and seemed to me mostly cobalt blue and cobalt turquoise. The same feeling of blue is carried through Sutro Heights and Lincoln Park; red and yellow seem to be missing in these sections of the city. The character of the water and the natural growth seems to be at one with the air around it, which in turn gives the same movement to the clouds. Golden Gate Park, which ends at the Pacific Ocean, uses all the transparent watercolors that Winsor & Newton offer. The Rose Garden has a wonderful studied beauty that is expressed in complementary colors. The Conservatory paintings are exaggerated in color, but to me they appear to be that way because the air is oppressive. In the performing arts stage lighting brings out extremes in color that become gorgeous and artificial and produces an effect that is different from anything else. That's why I particularly love to paint inside the theatre, whether it be backstage or in the house.

San Francisco is more than 150 years younger than New York and it is difficult to explain why San Francisco is as it appears. I think that Leonard Cahn has successfully done this in his factual and poetic style of writing.

JEAN PORTER

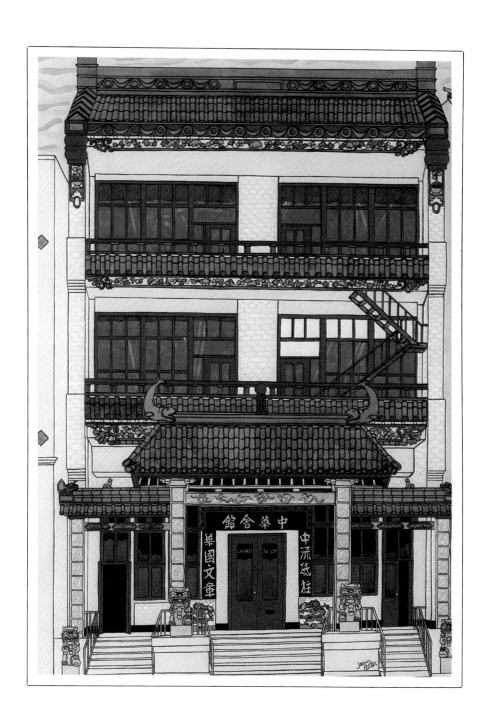

THE WATERFRONT

Of all the ports on the bay, San Francisco is blanketed under the thickest fog; its shores swept by the hardest winds and the strongest currents. In the early years it rose from the water in an almost unrelieved wall of hills and cliffs, surrounded on three sides by water and entirely separated from the rivers and valleys from which would come the grain, the cattle, and the ores to fill the holds of the docking ships. It was not at all the place that should have been chosen to build a port. That came about by errors and events unrelated to its attributes. San Francisco became, in fact, a port by accident.

In 1769, when Gaspar de Portolá sighted the Gulf of The Farallones near the entrance of the bay, he had been searching for *Monterey* Bay to establish a site for a mission. His starving, scurvy-ridden crew were so desperate they turned back without ever learning the importance of what they had stumbled upon. Two years later Pedro Fages led a second expedition north from San Diego still trying to find Monterey Bay, which was believed to be bounded on the north by Point Reyes. The explorers came up the valley and crossed the ridge above the site of Berkeley and there, a white man beheld the magnificent sweeping bay. "The Harbor of Harbors," "A prodigy of nature," they called it. Four years later Juan Manuel de Ayala on his tiny ship, *The San Carlos,* found the entrance to the bay that had been missed by ships sailing the coast for over 200 years.

As night fell, not knowing if he would be swept against the sheer red cliffs on either side or wrecked on unseen rocks, Ayala mounted the flood tide and sailed through the Golden Gate. It was 1775. Anxious to claim the territory for the Spanish crown, the viceroy in Mexico City sent Captain Juan Bautista de Anza, with a party of 240 men, women, children, and soldiers 2,000 miles to establish a fort. The following year, 1776, the Presidio and Mission Dolores were completed. The events were celebrated with a High Mass and the firing of cannons. These two developments determined the destiny of San Francisco.

Seventy years later the town of Yerba Buena (as it was then called) had a population of 200, mainly trappers who brought their hides to the Hudson's Bay Company and traders supplying the fort and the mission. Benicia, with a slightly larger population and, according to Bancroft, "on the strength of its superior advantages in possessing a fine harbor . . . and of easy access . . . rivers and valleys," was vying with Yerba Buena to become the major port. Each sought the name San Francisco so that it would be identified with the bay. Yerba Buena won the title in 1847, the year California declared its independence from Mexico and became a territory of the United States. In summing up the developments that led to San Francisco's emergence as the principal city and port of the bay, Bancroft wrote, "our seraphic father of Assisi [Saint Francis] remembered the honor, by directing to its shore the vast fleet of vessels which in 1849 began to empty here their myriads of passengers and cargoes of merchandise. This turned the scale, and with such a start and the possession of capital and fame, the town outdistanced every rival."

It was probably not the grateful spirit of Saint Francis that influenced the hundreds of ships and the cataclysmic growth but the existence of the mission and the fort. Because of the presence of these two settlements Yerba Buena had superior supplies. In fact, it was because of the mission and the fort that it was there at all. The ships entering the bay with their hysterical, excited crews and passengers desperate to reach the gold fields dropped anchor at the nearest port. They knew little of the geography of the bay, which placed Benicia much closer to the gold fields. Within months over 500 ships lay at anchor off North Beach. The population that had been 200 in 1846 and 767 in 1848 leaped to 20,000, then to 40,000 in 1852.

The indomitable growth was frenzied and chaotic. A law declared the shoreline of Yerba Buena Cove was not to be impinged upon. Nevertheless, by 1856 the cove had been entirely filled and eight piers had been built. The following year a law was passed permitting the construction of piers. Then it was discovered that the currents and tides swept the fill away from the base of the piers. The water of the bay flowed back in and turned the fill to liquid mud more treacherous than quicksand. People fell in and disappeared from sight, never to be seen again. Then in 1859 a bill was passed authorizing the construction of a sea wall; however, work was not started until 1867. It was a tremendous task. A trench sixty feet wide and twenty feet deep was dug into the floor of the bay and filled with rock blasted from the base of Telegraph Hill. The first segment was completed in 1878, and the entire Embarcadero was not completed until 1913. It extended from Fisherman's Wharf to Bethlehem Shipyard, an eleven-mile span with the Ferry Building in the center like a great symbol of the port's dominance. In its heyday, 50,000,000 people in a single year passed through its portals. It was indeed the hub of the city. In figure 1 the Embarcadero is viewed from beneath the San Francisco–Oakland Bay Bridge south of the Ferry Building in figure 2.

The building of the Embarcadero transformed the city and the waterfront in every way. The millions of tons of rock needed for the base were blasted from

Telegraph Hill, transforming its bayside slopes into cliffs. Coit Tower and Pioneer Park dominate the escarpments above Lombard Street. At the base of the hill, from Union to Bay streets, the narrow corridor created by the quarrying became the site of red brick warehouses needed for the burgeoning shipping industry.

The Levi Strauss development now occupies most of the shoreline, and only a few of the early multistory brick buildings remain. On Union and Sansome streets the Ice House, now a decorator center, was once the National Ice and Cold Storage Building that supplied great blocks of ice for the reefer cars that hauled fruit and vegetables east. On the corner of Greenwich and Battery streets the brick building with the classic cornices, arches, and corbeling was the warehouse for Italian Swiss Colony Wines, and a block farther on the corner of Lombard and Battery streets is the only building remaining of the huge Merchants Ice Complex that began at the turn of the century by shipping ice from Alaska for the fishermen, the produce market, and the ice-cream and cocktail trade.

The fishing industry was first dominated by the Chinese, then by the southern Italians and Yugoslavs, but by 1880 it was entirely controlled by the northern Italians, followed by the skilled fishermen who came from southern Italy and Sicily: the Aliotos, the Sabellas, and the Tarantinos, all from the same town—Palermo.

The bay was colorful with the fleet of lateen-rigged feluccas, the same sturdy, shallow craft that the fishermen had sailed on the Mediterranean. At first they brought their catch in to a makeshift pier at the base of Telegraph Hill. Then as the blasting and dredging for the sea wall began in earnest, they moved farther and farther north along the shore until they established themselves at Francisco and Mason streets, the present site of Fisherman's Wharf.

In the early years the catch from the sea and the bay was varied and bountiful, and fishing boats returned laden with rich hauls of rock cod, sardine, smelt, salmon, herring, perch, striped bass, crab, oysters, shrimp, squid, and even turtle. The sale of fish began long before dawn with peddlers and merchants haggling over price. Soon the loaded wagons and the Chinese hawkers with baskets of fish swinging from yokes across their shoulders went through the streets crying and blowing horns to attract the housewives.

The few restaurants that existed were small shacks where the fishermen gathered after the catch was unloaded to eat their bowl of rich chowder and drink wine, smoke, and talk.

Then Tomaso Castagnola, whose restaurant is still one of the most popular on the wharf and was the last to modernize, decided that he would try to sell seafood cocktails and fried fish to the people of San Francisco. In 1916 he opened the first restaurant to the public on Fisherman's Wharf.

By 1940 the restaurants of the Wharf were world famous. DiMaggios, Tarantinos, The Exposition, Aliotos, Sabellas, all names that helped create the industry, are still prominent on the wharf. Figure 3 shows the King-Knight Co. buildings viewed from a position by Scomas Restaurant and looks up toward Russian Hill. The boat on the scaling ramp in figure 4 is viewed from behind Castagnola's, and beyond the ramp are the sheds where the fish are cleaned and packed.

Today Fisherman's Wharf is a gleaming tourist attraction second only to Chinatown in its popularity. Most of the boats moored in the tiny harbor are rented for sport fishing. Across the street from Castagnola's and down the block, almost at the edge of Aquatic Park, is the Cannery. It was the Del Monte Fruit Cannery and has now been handsomely remodeled into a bazaar housing restaurants, art galleries, boutiques, a theatre, and other attractions. Figure 5 shows the gaily pennanted rooftop with the Shang Yuen Restaurant. The Cannery is almost at the boundary between Fisherman's Wharf and Aquatic Park.

Of all the 120 small parks that garland the city's landscape, none is as frequented or has so many attractions as Aquatic Park or the Marina Green on the shore of the bay west of Fisherman's Wharf.

Aquatic Park is the most crowded, with people of all ages enjoying its many interests. The view in figure 6 looks out to the bay and the curving pier that encloses one side of the tiny cove. On the opposite side is the Hyde Street Pier, a floating maritime museum to which are moored antique ships, scows, schooners, lumber schooners, a coal "puffer" brought from England, and other ships and memorabilia of colorful bygone days. Up the hill in the park next to the National Maritime Museum is the famous bocci ball court where the citizens of the Italian community can be seen on almost any pleasant day competing with skill and enthusiasm (fig. 7). Across the street from the park on the corner of Hyde and Beach streets is The Buena Vista Café (fig. 8). It has been for many years the most popular bar in town. The festive spirit of the park seems to fill its ever-crowded, large, high-ceilinged room.

The Marina Green was created by landfill to form the site for the 1915 Panama-Pacific International Exposition that celebrated the completion of the Panama Canal and San Francisco's phoenixlike rebirth from the earthquake and fire. On the western end of the

Marina is the Palace of Fine Arts, the only building remaining from the elegant concourse. Designed by Bernard Maybeck, it was built of papier-mâché and was intended to last only through the fair, but in 1973 it was restored in concrete. Almost every activity is enjoyed on the green from touch football to sunbathing amid the scores of kites that fill the air with bright-colored shapes against the blue-green sea and the red bridge. On the water's edge is the yacht harbor (fig. 9) and the St. Francis Yacht Club.

Beyond the Marina Green and the kite flyers is the Golden Gate Bridge (fig. 10; 1933–1937) joining San Francisco to Marin County, one of man's engineering masterpieces. Until the construction of the Verrazano Bridge (1964) in New York, it was the longest single-span bridge in the world. Twice the time needed for construction was consumed in overcoming the opposition of doubters, of the Southern Pacific Railroad that owned a great part of the ferry system, of military leaders, of shippers, and of an array of thirteen engineers, including the city engineer who said that it couldn't be done and that it was economic madness to spend $35 million on such a hopeless project. Once construction began, the battle with the bay's currents and tides almost defeated the deep-sea divers, riggers, and steelworkers. But in the end it was acclaimed as an engineering marvel. The three-quarter-mile-long span, so delicately proportioned and so dramatically vantaged, is an aesthetic marvel as well.

The San Francisco–Oakland Bay Bridge, until 1979 the longest bridge system in the world—eight and a quarter miles long—was completed in 1936, six months earlier than the Golden Gate Bridge, and just thirty years after the city was razed by earthquake and fire.

With the completion of the Panama Canal and the Embarcadero, San Francisco became the fourth most important port in the world. With the completion of the bridges, it became the hub of the entire Bay Area and the largest business and banking center in the West.

The waterfront is changing rapidly. Pier 39 has been transformed into a recreation and shopping center. Some of the restaurants that have long been the eating places of sailors and longshoremen are being turned into fine restaurants. China Basin, once the site of a Chinese shrimpers' camp, is now the location of a large office building, and along the estuary are arks and Blanche's popular restaurant (fig. 11). The active piers are now south of the basin almost as far as Hunter's Point.

1. The Embarcadero near Rincon Hill and the Bay Bridge

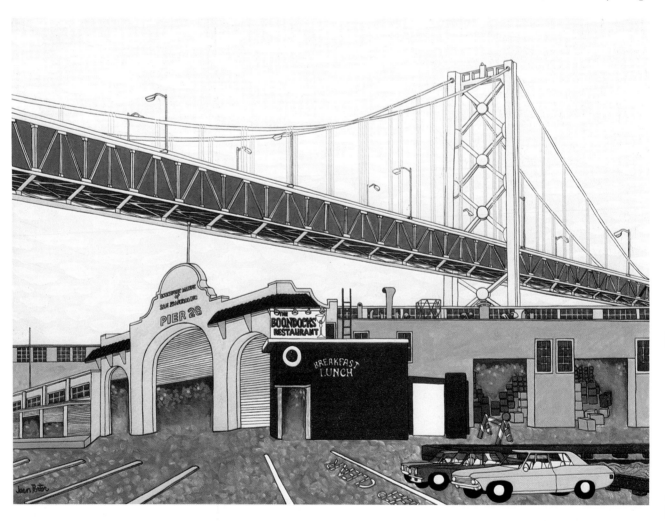

2. The Ferry Building near the Golden Gateway

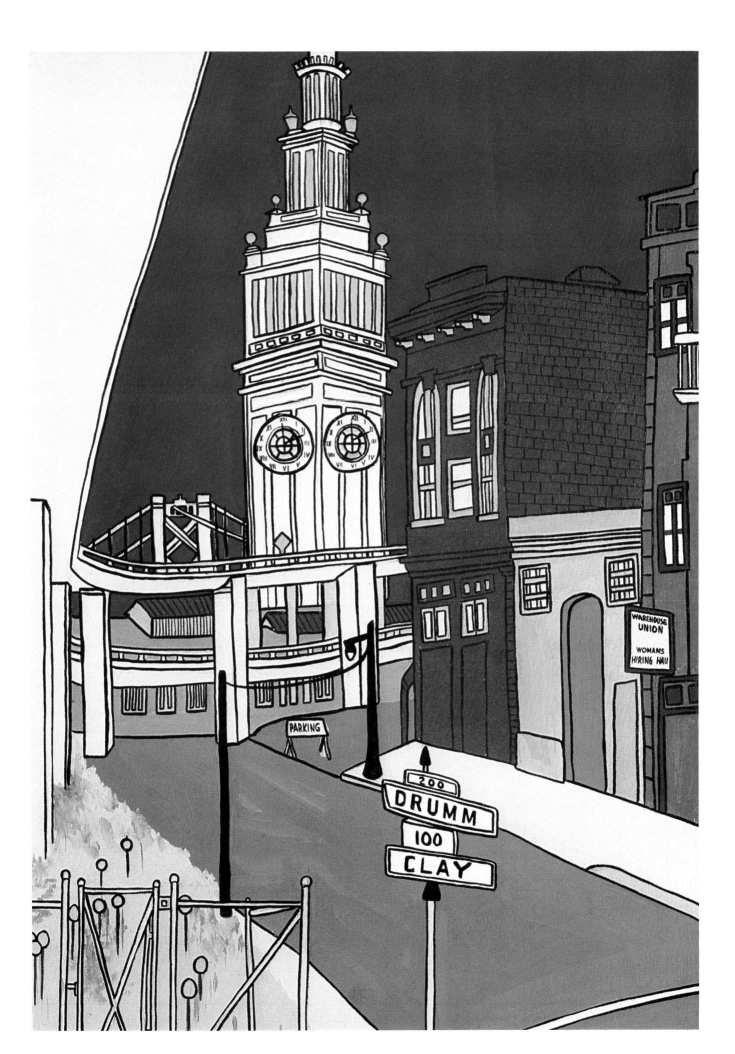

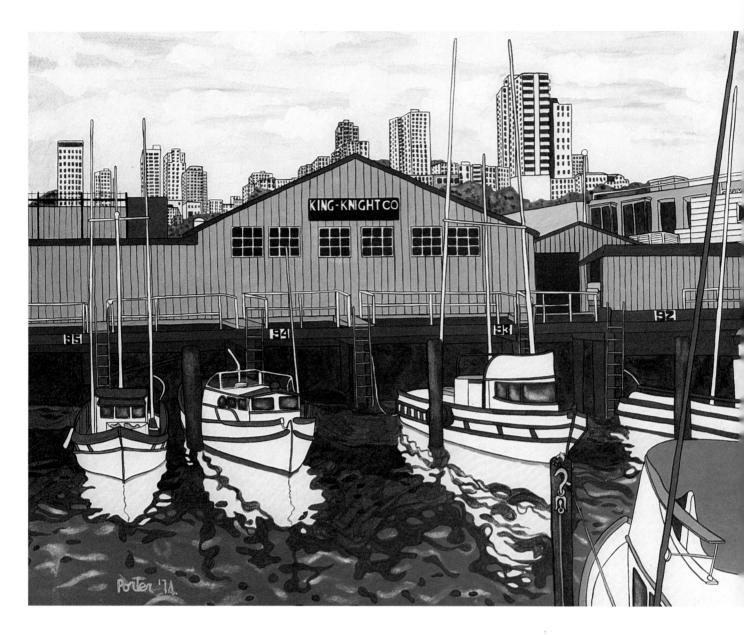

4. Behind Castagnola's Restaurant on Fisherman's Wharf

3. On Fisherman's Wharf Looking up to Russian Hill

5. The Cannery at Leavenworth and Beach Streets

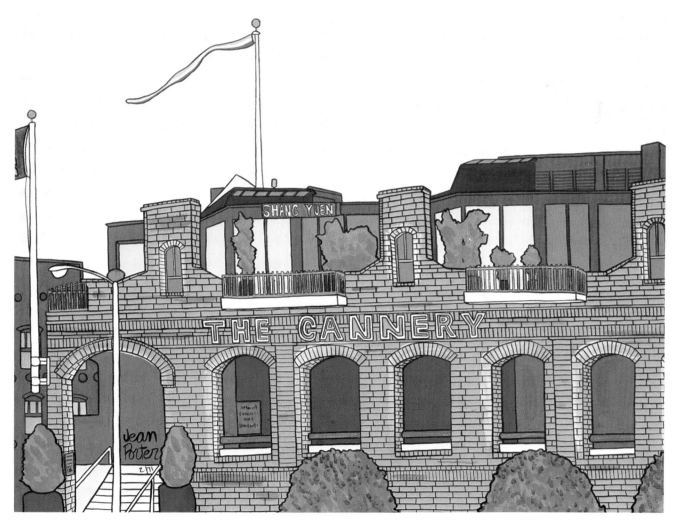

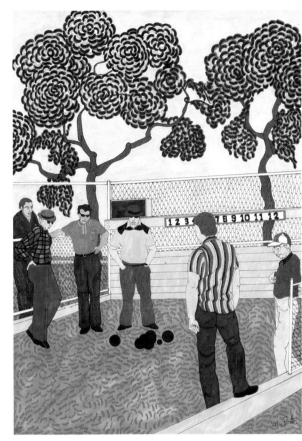

6. Aquatic Park—Municipal Pier and Marin County in Background

7. Bocci Ball in Aquatic Park at the End of Van Ness Avenue

8. The Buena Vista Café at Hyde and Beach Streets

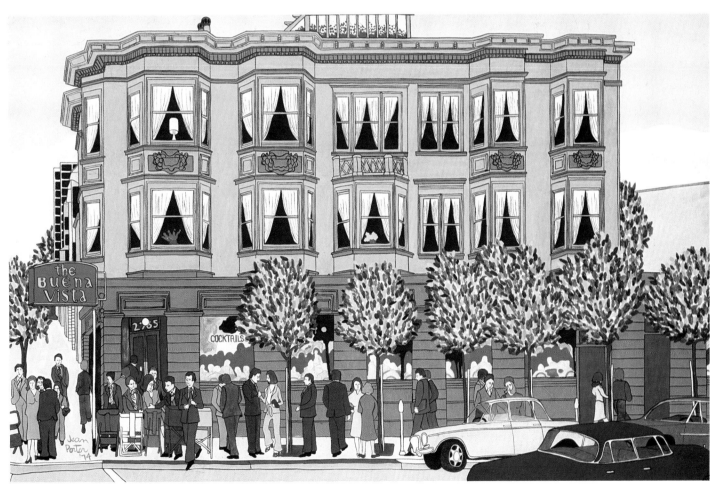

9. San Francisco Marina next to the St. Francis Yacht Club

10. Kite Flying on the Marina Green—Golden Gate Bridge and Marin

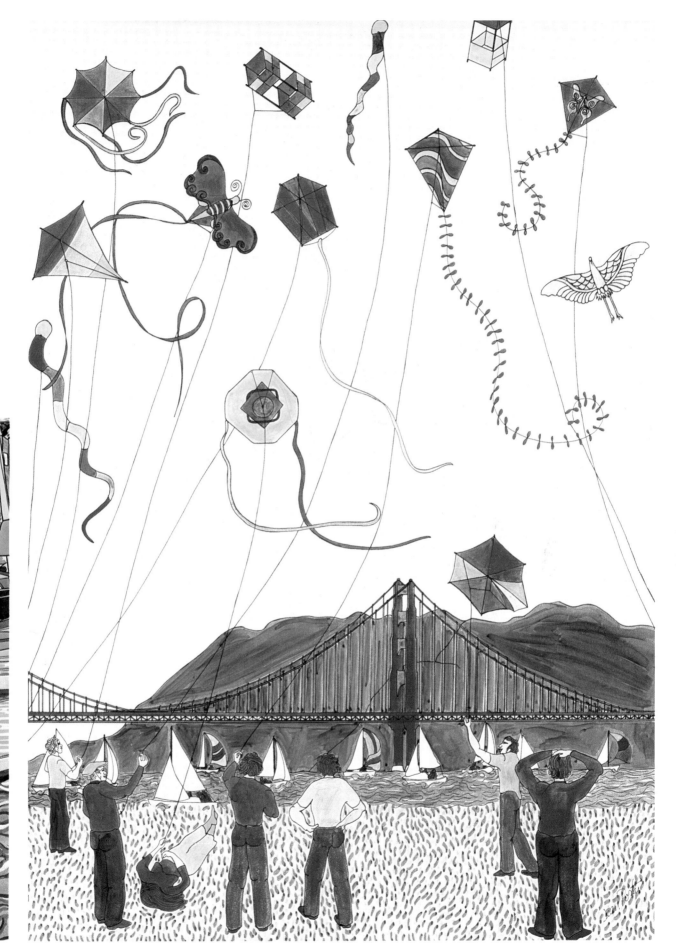

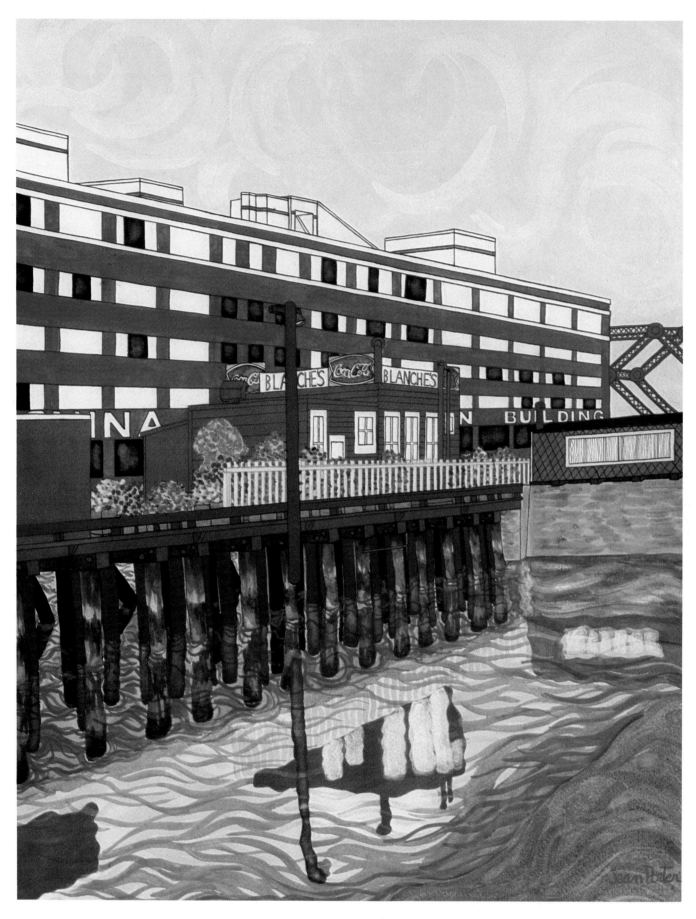

11. **China Basin on Channel Street near the Embarcadero**

THE FINANCIAL DISTRICT
AND DOWNTOWN

Forty million dollars in gold was pouring into the city each year from the sluice boxes and diggings but there was almost no *money*. Only a small amount of U.S. legal tender existed in San Francisco, but francs, Spanish pesetas, rupees, pesos, reales, florins—any coin was used. Gold wire the length of a dollar bill was acceptable as legal tender and would also be cut into eight pieces to make small change, thus making popular the expression "two bits, four bits," and so forth. In stores, saloons, and brothels a miner would hold out his sack of dust for the bartender or madam to take a pinch. One pinch was equal to a dollar. A dozen different assay offices coined gold slugs of denominations from five to twenty-five dollars. The amount of gold in each denomination varied greatly.

Banks were rapidly organized. Any storekeeper with scales and a safe in which to store the gold could become a banker. Gold taken on deposit was shipped back East in exchange for drafts from the East Coast banks. Eight to fifteen percent interest was charged monthly on real estate loans. By 1855, there were forty-two banks. That year, following a decline in the mine production, twenty-two banks failed.

In 1852 the first stable banks were formed by the operators of large mines and by the express companies that hauled the gold—the most important of these was Wells Fargo. The Bank of California was established by William C. Ralston and Darius Ogden Mills of the Comstock Mines in 1864. New banks sprang up rapidly, others disappeared. By 1880 there were 111 banks in the state. Only 8 of these were national banks; the others were incorporated companies not subject to national banking laws and foreign banks including the Rothschilds and Lazard Frères.

Montgomery Street from the very first was the main street of finance and business. It was a sea of mud. NOT PASSABLE signs were soon supplemented with NOT JACKASSABLE when mules and horses fell into the black ooze and disappeared. In spots along the shore it was equally treacherous and drunks were known to lose their footing and drown. Ramshackle buildings were thrown up along the street. The most stable structures were the ships hauled up and beached above Sansome Street to be used as warehouses, stores, and even hotels. Again and again the makeshift sprawl was razed by fires deliberately set by miners on a spree or by the hooligans of Sydney Town.

One of the first solid structures was the Montgomery Building built in 1853 by Henry Halleck who became Chief of Staff of the Union Army. When completed, it was four stories high and stretched from Washington Street to Merchant Street and halfway to Sansome Street. In the center was a beautiful Florentine garden. The foundation was formed of great redwood logs floated on the mud. During construction the town's wiseacres called it "Halleck's Folly." Some predicted that it would float across the bay and others that it would sink out of sight. But it stood solidly until 1958 when it was demolished. The Transamerica Building, also known as the Pyramid, was built on the site.

The Montgomery Building was the center of the street's activities, housing the law library and the Adolph Sutro Library. George Sterling and Robert Louis Stevenson had studios there. In a small office on the fourth floor Sun Yat-sen plotted the overthrow of the Ch'ing (or Manchu) dynasty. Across the street was the headquarters of the Pony Express. On the Merchant Street corner was Poppa Coppa's, a restaurant where the Telegraph Hill artists and bohemians gathered. Jack London joined George Sterling, Ambrose Bierce, the Irwin Brothers, Charles Stoddard, and many others. On the north corner was the Bank Exchange Saloon, the most popular bar among the businessmen. It was here that Frank Norris gathered material for his great novels that described the struggles for power surging along the muddy street outside.

More and more buildings were erected toward Market Street, where the curving shore left a wedge of more compact terrain after the land had been leveled and pushed into the cove. The Lick House, the Russ Hotel where the Russ Building now stands, the Occidental Hotel, the first Mint on Commercial, the Claus Spreckels Building on Market Street, the Bancroft Building, the de Young Building, The Mechanics' Institute on Post Street were built, and finally the great Palace Hotel in 1875—seven stories high, with 800 rooms, called the "world's grandest."

The district of big business and high finance was established with Montgomery Street as the nerve center. At the north end was the Barbary Coast and at the south end Market Street. In 1905 the Columbus Tower was constructed on the corner of Columbus Avenue and Kearny Street by Abe Ruef, who was the power behind a corrupt City Hall and the whirlpools of vice on the Barbary Coast and in Chinatown. From his offices on the top floor he could survey with pride his wild domain. Figure 12 shows the dome-crowned building and, almost symbolically looming in the background, the Bank of America World Headquarters building. At the south end of the street the massive and austere Palace Hotel represented the emerging power of the financial district (fig. 13). Everyone stayed there: Oscar Wilde, Sarah Bernhardt, Anna Held, Lillian Russell, President Grant. Its Fri-

day night dance was the weekly social event. Along the street paraded the ladies and men with their expensive Paris gowns and London-tailored suits, flashing slippers and polished boots, with muddy water squirting up between the planks of the boardwalk with every step.

The Palace Hotel withstood the earthquake, but although the building contained a tank holding 750,000 gallons of water, it was gutted by the fire. Enrico Caruso, who had sung in *Carmen* the evening before at the Tivoli, fled his room and never returned to San Francisco. In 1909 the hotel was rebuilt. The glass-domed Grand Court, the ornate carriage entrance, was rebuilt into a banquet hall and christened the Palm Court, and for many years symphony concerts were performed there. It is now known as the Garden Court (fig. 14).

Only a few buildings survived the fire. The Barbary Coast was destroyed. It was rebuilt and flourished again for a short time, but the Temperance League, police restraints, and finally Prohibition put an end to it. But the financial district swiftly became the greatest business center outside of New York and Boston.

The best restaurants were located in the district and some of them dating from the Gold Rush still remain. Perhaps the most famous of all is Jack's (fig. 15). The simple, confident facade and the imposing gold-leaf sign are characteristic of these restaurants that started by serving the miners; Tadich's built in 1849 and relocated to California Street to make way for the Embarcadero Plaza; The Old Poodle Dog, its name adapted by the miners from Poulet d'Or; Sam's Grill; Henry's Fashion; and farther downtown John's Grill, patronized by Dashiell Hammett and his fictional hero of *The Maltese Falcon*, Sam Spade.

Ten years later after the fire the rebuilt city had become the center of almost every business function on the West Coast. The prestigious printing and lithography industry was begun by Max Schmidt, a young German immigrant, with an investment of eighteen dollars. The firm he started, now Stecher-Traung-Schmidt, is one of the largest. Figure 16 shows the view down Second Street; the Stecher-Traung-Schmidt Building is seen at the end of the street with its gold-colored pyramid-shaped roof. The Canessa Building in figure 17, with its extravagant, playful facade, expresses some of the pride of the industry.

In 1850 Union Square was created on land presented to the city by John Geary, the first mayor. Only three blocks west of the financial district, it is the center of the fine shops, hotels, restaurants, and theatres. It is indeed the heart of the city San Franciscans love. The cable car clangs down Powell Street. The imposing St. Francis Hotel covers the block facing the square on the west. First built in 1904, and destroyed by fire, it was rebuilt in 1908. The square and the hotel are shown in figure 18. Nearby are the Clift, the Sir Francis Drake, and the Union Square Hyatt Hotels, but the St. Francis is the hub.

Along Union Square and in the surrounding area are some of the city's finest stores. On Geary Street facing the park are Macy's (fig. 19) and I. Magnin's. On Post Street Gump's (fig. 20) was first built for Solomon Gump and is known the world over for its crystal, silver, jewelry, and jade. Sherman Clay and Co. located on Kearny Street opened its first shop in 1870 to repair music boxes and is now the center for fine musical instruments. Shreve and Company on Grant Avenue at Post Street is one of the most famous jewelers in the West. A new Neiman Marcus store will replace the City of Paris store (fig. 21) located at Geary and Stockton streets. The beautiful four-story rotunda with the stained-glass dome will become a part of the new building. Saks Fifth Avenue (fig. 22) was for many years at Grant Avenue and Maiden Lane. Their new location is on the corner of Post and Powell streets facing the square.

The square itself, with its imposing Navy monument that commemorates Admiral Dewey's victory at Manila, is filled with shoppers and visitors who come to enjoy the flowered park, the mimes, the occasional concerts, or just to watch the passing parade.

12. Columbus Tower at Columbus Avenue and Kearny Street

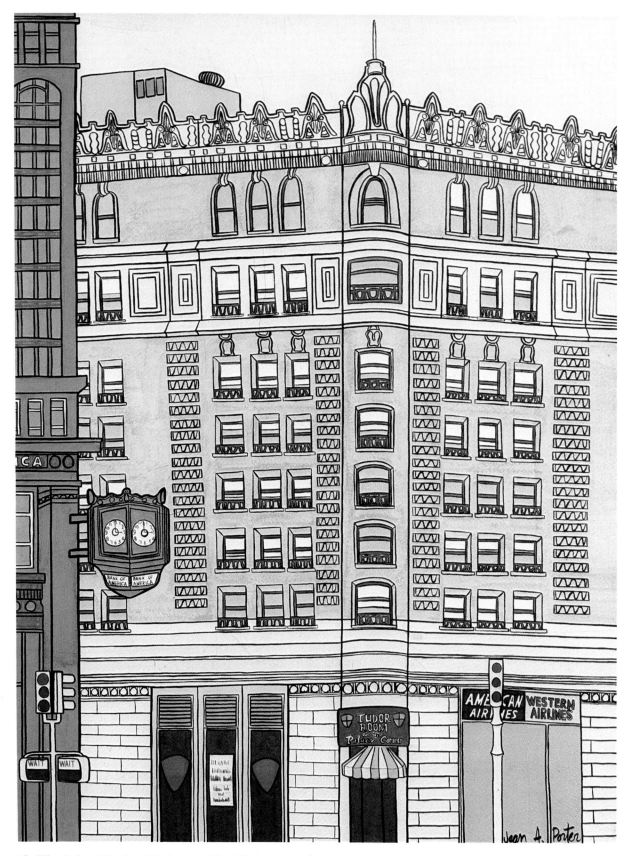

13. The Palace Hotel at Market and New Montgomery Streets

14. The Garden Court at the Palace Hotel

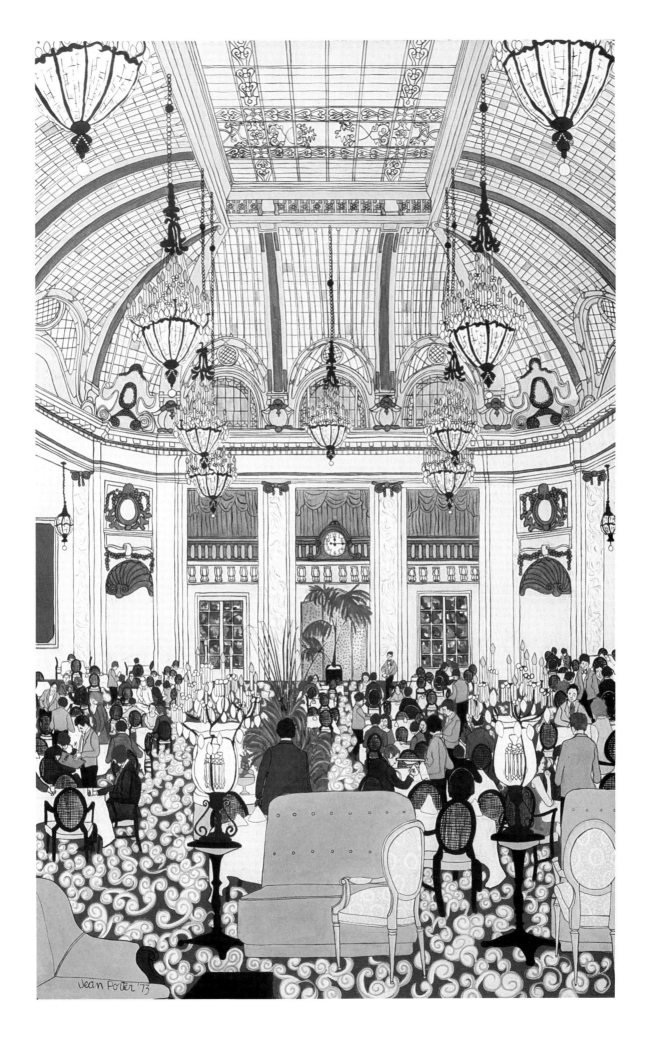

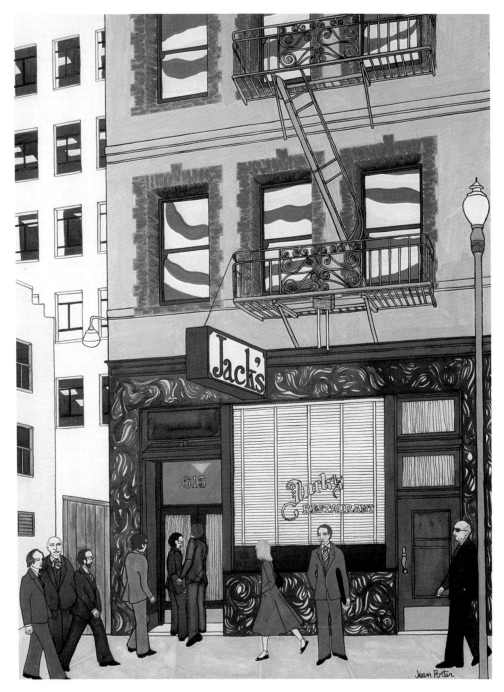

15. Jack's Restaurant at 615 Sacramento Street

16. Looking down Second Street to China Basin from the Equitable Life Building

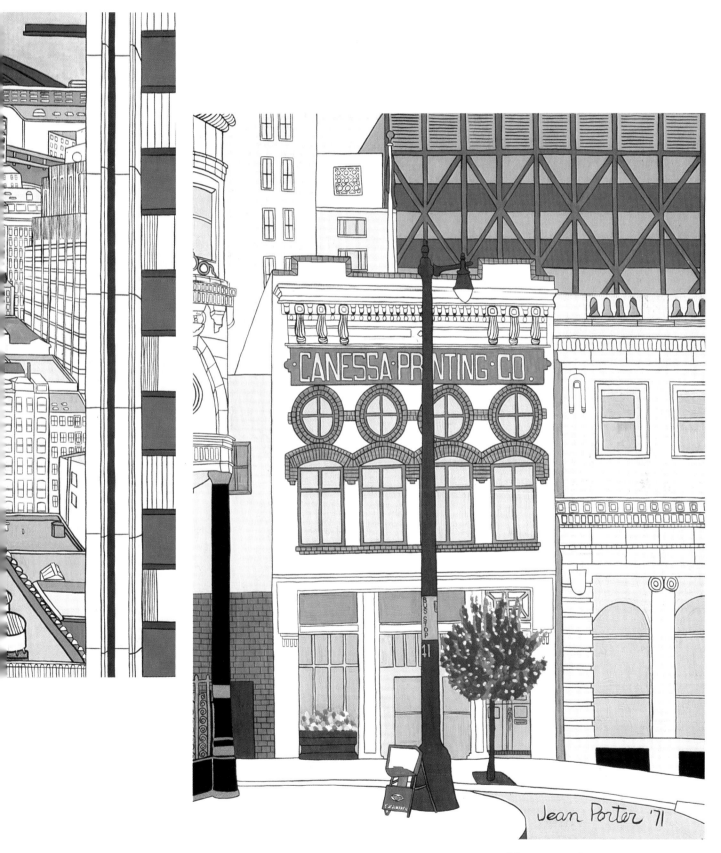

17. Old Canessa Printing Co. Building on the 700 Block of Montgomery Street

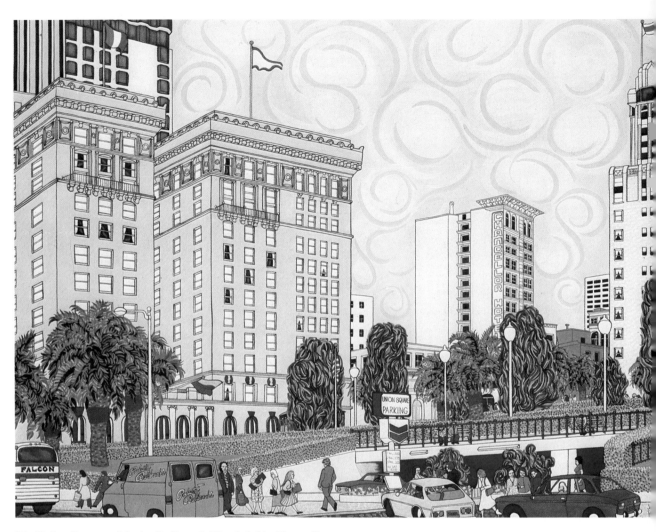

18. Union Square with the St. Francis Hotel (left), Chancellor
Hotel (center), and Sir Francis Drake Hotel (right)

20. Gump's at 250 Post Street

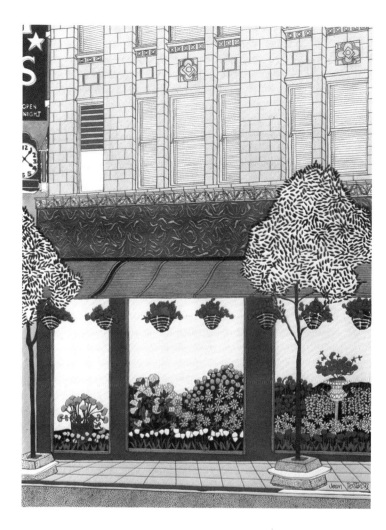

19. Macy's Department Store at Easter

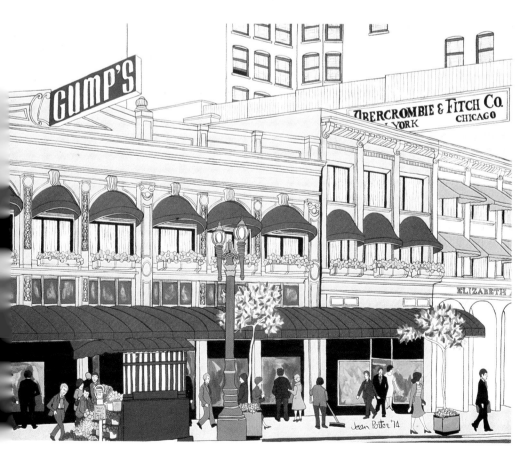

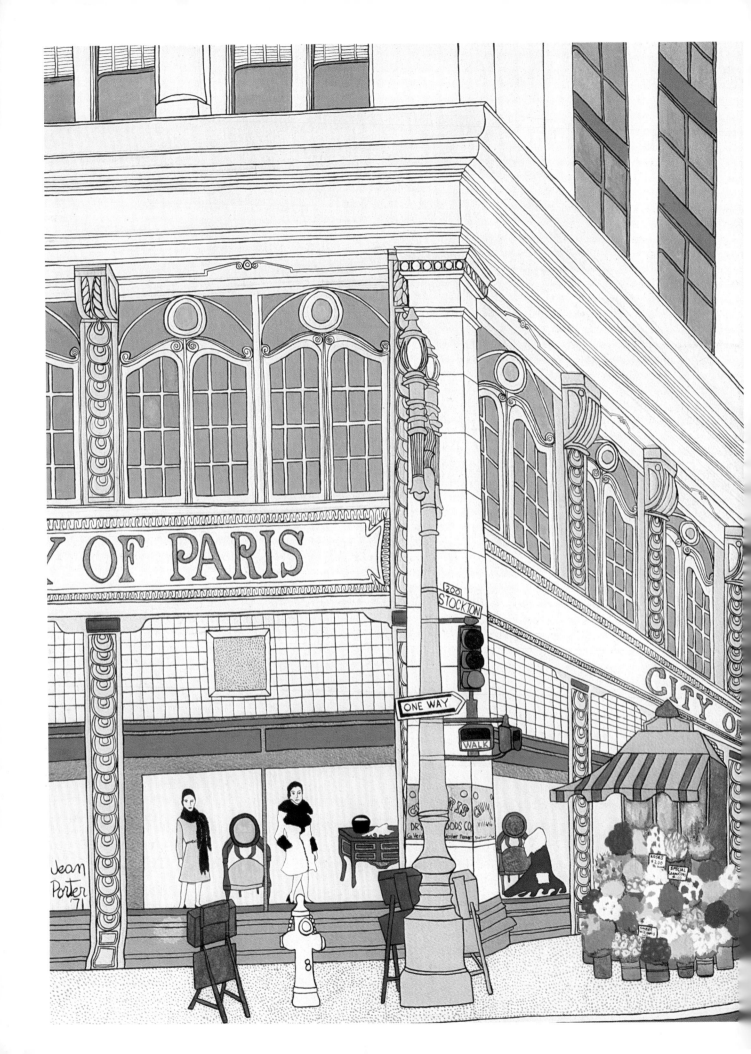

22. Saks Fifth Avenue when Located at Maiden Lane and **Grant** Avenue

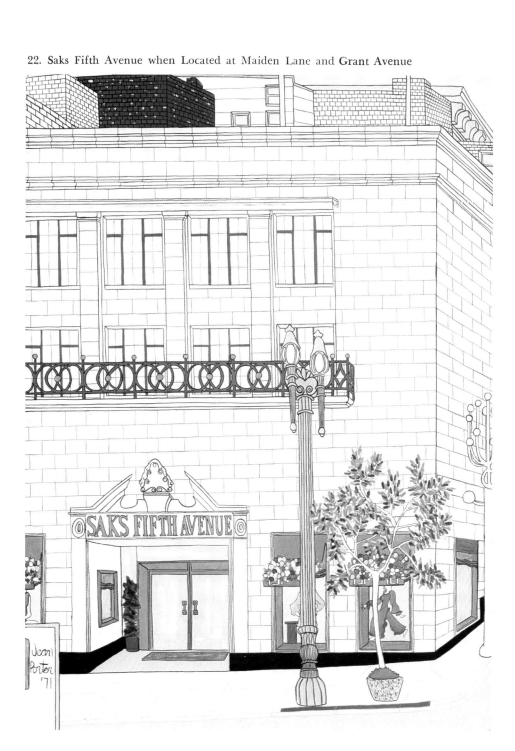

NORTH BEACH AND TELEGRAPH HILL

No other city in the modern world has exploded into being so suddenly or transformed itself so swiftly—from tent city to "Wall Street of the West" in one hundred hectic years—and in the entire city no other neighborhood has contributed so much to its stability, growth, and color as has North Beach.

When the Italian immigrants began arriving in the early 1850s, Broadway was a narrow dirt street cut into the slope of Telegraph Hill. It extended from Clark's Landing, a rocky outcrop, to Stockton Street at the foot of Russian Hill. Above Broadway was Sydney Town, a settlement of exiles from the Australian penal colony, and below the hill and to the west was Little Chile, a sprawl of miserable huts and tents inhabited by Peruvians and Chileans.

Belongings on their backs, the immigrants made their way into the new land amid a hail of stones and curses and taunts from the wild inhabitants and halted as soon as they found a place to erect a shelter; first along Grant Avenue, then up Telegraph Hill, tier upon tier as more settlers arrived, so close they could reach each other by ladder, until it resembled a cliffside Mediterranean village. They worked hard at whatever jobs they could find and as soon as enough money was saved, another member of the family was sent money for passage.

Within a few years they had begun to dominate the fishing industry. They established small farms on rented land in the Mission District, Visitation Valley, Noe Valley, Lake Merced, Hayes Valley, and down the peninsula as far as Colma. To assure an orderly outlet for their crops, they formed an association of growers, rented a square block at Davis and Pacific streets, and built a large shed containing rows of stalls and bins. By 1900 the Colombo Market had become the largest vegetable market in the world occupying three square blocks where the Golden Gateway now stands.

They brought new vegetables to the people of San Francisco: broccoli, artichoke, fava beans, zucchini, eggplant, bell pepper, cauliflower, and wonderful fragrant spices and herbs such as fennel, rosemary, parsley, oregano, marjoram, sweet basil, and garlic. They created the great Fontana and Del Monte canneries. They brought together the grape growers and formed Italian Swiss Colony Vintners, created the flower market center, the spice import market, Ghirardelli's chocolate, and absorbed the Alaska Packers. But of all the achievements of the San Francisco Italians in the world of business none can compare with young Amadeo Giannini's bank.

When he was thirty-one, Giannini retired from a successful commission house business to pursue his dream of a bank that would serve his beloved countrymen, who were arriving in ever greater numbers. In 1904 the bank opened, guided by the unique philosophy that money could be lent to immigrants whose only collateral was a willingness to work hard. The bank began to prosper at once, perhaps because the penniless arrivals had no other place to go for help. It may be that Giannini's bank, guided by his skill and daring, would have become enormously successful in any case, but it was an irony upon irony resulting from the earthquake and fire that catapulted the bank into prominence.

The bank had been open barely two years when the fire swept the city, and Giannini had not yet the means to build a vault as had the other banks. When he saw the fire roaring up from Montgomery Street, he rushed to his friends in the produce market and he loaded the bank's money and records into a borrowed wagon and fled to San Mateo.

The day after the fire had died, he set up his bank on a makeshift table on the Washington Street wharf with his money and records in the wagon behind him. The large banks discovered that the intense heat had sealed their vaults shut and they were warned that to force them open before they had cooled could cause the contents to burst into flames. So, for ten days, Amadeo Giannini had the only bank in town.

All about was desolation, but some shacks on the hill still remained. They had been saved when the Italian hill dwellers soaked their blankets in wine and covered the walls and roofs, and formed a bucket brigade that poured wine to halt the fire. The water mains had burst. Three days later, when the fire had burned out, with absolutely no water, the people drank wine, and soon the horses and dogs drank wine. A scene of chaos, grief, and insane hilarity greeted Giannini.

He started making loans as quickly as he could. North Beach was the first to rebuild and Giannini never looked back. His Bank of Italy became the Bank of America, the largest in the world, with headquarters on California Street. Just as the bank dominates the financial scene, the building dominates the cityscape. Parts of it can be seen in figures 12, 20, 23, and 67.

In the first thirty years 2,500 Italians had settled in North Beach. Almost all were from northern Italy. In 1880, attracted not by gold but by the discovery

of the fertile golden-brown valleys and the rich fishing grounds, the great migration from Italy began. The cove was already filled in, Broadway had been widened, and North Beach had become a geographic area. It was bordered on the south by Broadway, which divided it from Chinatown, on the west by Russian Hill, and it extended up Stockton Street and Columbus Avenue as far as Francisco Street. By 1900 the Italian population of San Francisco had reached 10,000, and North Beach had become a complete community in itself, with Italian newspapers, printing shops, bakeries, groceries, delicatessens, wineries, restaurants, theatres, special kitchenware shops such as Thos. Cara, Ltd., on Pacific (fig. 23), and churches with services in Italian. Vaudeville and drama were produced in a score of theatres on Broadway and Columbus Avenue. Opera tickets cost as little as five cents. By then the strong family community had forced the hoodlums of Sydney Town and the prostitutes and pimps down to Pacific and Jackson streets where they settled and established the beginning of the Barbary Coast.

In the 1920s small family-style restaurants sprang up. They were everywhere, on Columbus and Grant avenues, Stockton, Green, and Powell streets. Broadway was a street of restaurants, theatres, and small hotels such as those in figure 24. They began to attract diners from the rest of the city.

Washington Square had become the heart of North Beach. The land was donated by John Geary, the first mayor, who had also donated the land for Union Square.

Then in the 1930s, with the end of Prohibition, a change began to take place. Some of the restaurants were remodeled into elegant dinner houses: Ernie's, Fior d'Italia, The Blue Fox, and Alfred's. The most famous of all, into the late 1950s, was Amelio's, where they claimed you could dine on any food from any part of the world. Original Joe's and Vanessi's began an entirely new style of restaurant: the counter kitchen. It has been copied over and over and always with a name that includes "Joe's," that is, Joe's of Marin, Joe's of Westlake, Joe's of Sonoma, and so forth. The word *Joe's* instantly signifies the style of cooking and serving.

Telegraph Hill achieved significance from the very beginning. In 1850 a tall, thirty-foot mast with semaphores was constructed to signal the approach of each ship as it was sighted by telescope. Each arrival was a very important event. But the most important of all the ships that sailed into the harbor

were the Pacific Mail side-wheel steamers that carried the only news from the outside world. Banks had colored cards printed with the various signals. No sooner were the semaphore arms raised at right angles, signifying the arrival of a side-wheel steamer and the mail, than the people rushed to the top of the hill until they could sight the mail ship by naked eye, then back down the hill to the post office. The signal of the extended semaphore arms was so well known that one night during a theatrical performance of *The Hunchback* the hero threw his arms out wide and cried, "what does this mean, my lord?," and the audience shouted back, "side-wheel steamer!," bringing down the house.

In 1870 a storm blew down the semaphore and the look-out station. They were never rebuilt. A telegraph line had been strung in 1853 from Point Lobos to the hill and then to the Merchants Exchange building on Washington Street near Montgomery Street, thus giving Telegraph Hill its name.

From the first the hill attracted artists. It harbored Mark Twain who complained about the wind; Charles Stoddard who complained about the goats; Robert Louis Stevenson; Bret Harte; Ambrose Bierce; George Sterling, San Francisco's unofficial poet laureate; and others. And from the very first the hill symbolized something special to the people. On Sundays they crowded the hilltop to gaze at the water and the hills beyond and to watch the tall ships sail grandly through the Golden Gate from the sea. George Sterling wrote a stanza often quoted in those days: "At the end of our streets is sunrise;/ At the end of our streets are spars;/ At the end of our streets is sunset;/ At the end of our streets—the stars."

Fifty years later, on the very edge of the cliff above Lombard Street, Pioneer Park was built and in its center Coit Tower. The money was a bequest from the estate of Lillian Coit. Arthur Brown, Jr., the architect who had designed City Hall, was retained, and in 1934 the tower (fig. 25) was dedicated. A rich growth of succulents has taken root on the rock face below the tower (fig. 26). Figure 27 shows the view from Napier Lane looking down the Filbert Street steps. On both sides are the lush delightful gardens planted and tended for many years by Grace Marchant, a hill dweller. In the distance below are the Embarcadero piers, the bay, and sailboats.

The observation deck of Coit Tower is 500 feet above the bay and is the first sight to greet the seaborne traveler. Among its most famous aspects are the murals that cover the walls of the first and second

floors and the stairway between. It was the first project funded by the Public Works of Art and the federal government. Of the sixty artists who worked on it, most lived in other parts of the city and most were still unknown. Ralph Stackpole, Maynard Dixon, Lucien Labaudt, Bernard Zackheim, Otis Oldfield, and Victor Arnautoff were among the better-known artists who were involved in its organization and execution. The murals represent all political facets and all shadings of political philosophy. When they were finished, North Beach and the hill were once again becoming a bohemian center.

By the late 1950s North Beach had begun to lose its exclusive ethnic character. The Italians who prospered had moved away to other parts of the city. Broadway became the city's street of entertainment and dining. Most of the family-style restaurants disappeared. As the Italians departed from Grant Avenue, the stores and flats were taken over by artists and bohemians. Figure 28 shows the colorful pattern of rooftops viewed from Green Street above Grant Avenue. Avrum Rubenstein and Peter Macchiarini opened studios and galleries in stores. Others like Peter LeBlanc, George McChesney, Lou Austin, and George Post worked and lived in the flats above and up the hill. They organized the Grant Avenue Street Fair that attracted artists from all over the city. Lawrence Ferlinghetti opened City Lights Books in 1956, which at once became a center for writers and poets and bohemians (fig. 29). Also seen in the painting is Henri Lenoir's Vesuvio. Across Columbus Avenue, La Bodega and La Tosca all became hangouts for the bohemians. North Beach was a vital creative center. On Broadway some of the best entertainment in the country was offered. Enrico Banducci's Hungry i and Purple Onion booked beginners like Barbra Streisand, Mort Sahl, and Lenny Bruce. At the Jazz Work Shop were Charles Mingus, Art Lake, Cannonball Adderly, and at the Matador were Charlie Byrd, Vince Guaraldi, and Oscar Peterson. The Off Broadway had Cal Tjader, Carmen McCrae, and Kenny Burrell. Turk Murphy opened Earthquake McGoons; Kid Orry, the Tin Angel that featured Odetta. There was live opera at the Bocci Ball. Then, suddenly, ridiculous occurrences transformed both the artists' world and the Broadway entertainment scene into travesties of themselves.

A dingy little coffee house on Grant Avenue and Union Street called the Co-Existence Bagel Shop had begun to hold forums, and the police several times broke up the meetings, creating headlines. At about the same time Ferlinghetti's City Lights Publishing House published *Howl* by Allen Ginsberg. The police repressed it, and Ferlinghetti was brought to trial for publishing obscene literature. The trial was front-page news throughout the country. Then Jack Kerouac's *On the Road* was published, and a crazy cult was formed and a new "bohemian" trekked to the city. Night after night the streets teemed with people all dressed alike with berets, dark glasses, and trimmed beards. Most of the hardworking artists left. Ferlinghetti was acquitted but by then his bookstore was crowded seven nights a week and was copied throughout the country.

At almost the same time at the Condor, a nightclub that featured dancers and music, Carol Doda, the prima go-go dancer, bared her bosom. The police raided the Condor and arrested the entertainers and the owners. At once the press headlined Carol Doda's bare breasts. Represented by two of the most flamboyant and talented local attorneys, Melvin Belli and James Hallinan, the topless act was legitimized. At once the Condor was jammed with people, and overnight the street changed. One after another restaurants and theatres closed and reopened as "topless joints." The crowds in the streets grew and changed into an excited parade of pleasure seekers. Now hawkers in the doorways harangue the crowds. Porno movies and massage parlors have taken the place of the sausage company, small Italian bars, and restaurants. Garish electric signs light the street, each claiming greater lascivious daring: nude coeds, love acts, topless, bottomless, and nude lady wrestlers. It is as if the Barbary Coast has had a wild rebirth. Figure 30 catches the night scene and the mood of the parading revelers along the street in front of Enrico's, often described in Herb Caen's column.

The Italian population in San Francisco, now numbering 80,000, has departed in large numbers to other parts of the city. The great increase in the Chinese population has seen their restaurants and shops spread across Broadway into North Beach along Stockton Street and Columbus and Grant avenues. The Napoli Market (fig. 31), a "typical" Italian neighborhood grocery, is now owned by Chinese. Down the alley from City Lights Books is now the Chinese Museum. Chinese children hurry along Broadway to school oblivious of the huge posters of nudes that they pass.

But again new legitimate theatres and entertainment are making their appearance—a new constituency, new faces, new crowds, and once again the street changes.

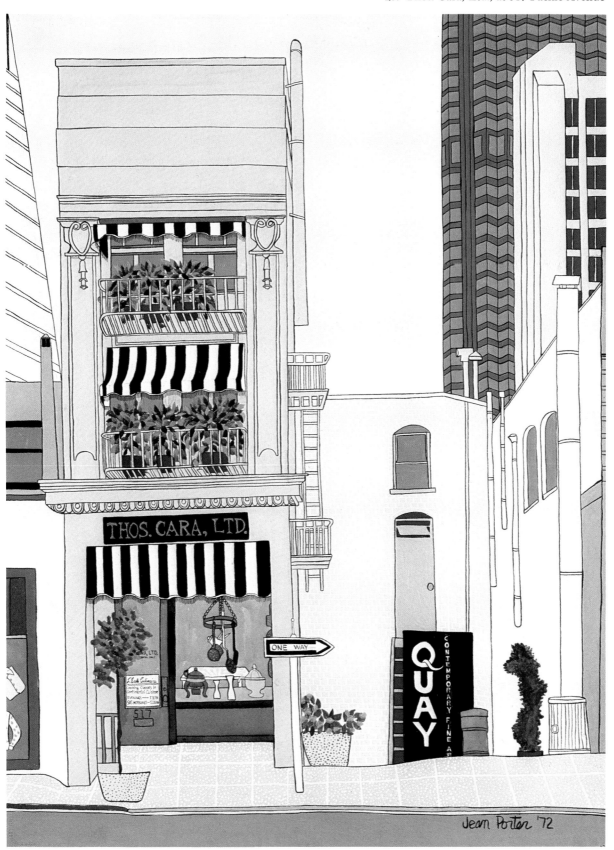

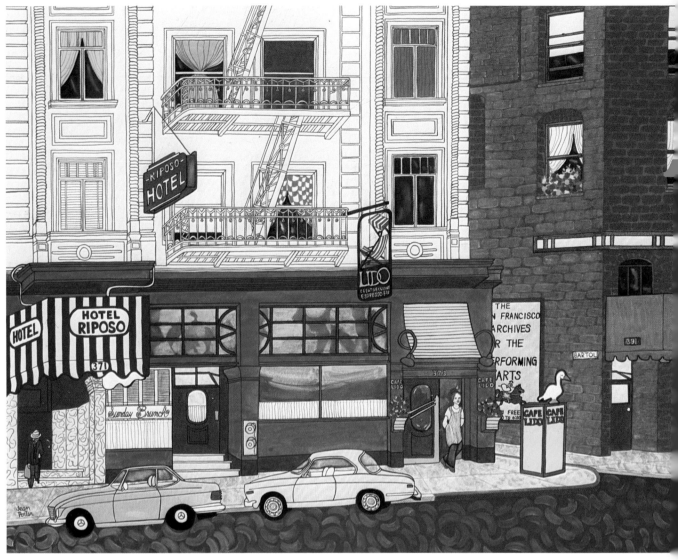

24. Café Lido at 373 Broadway

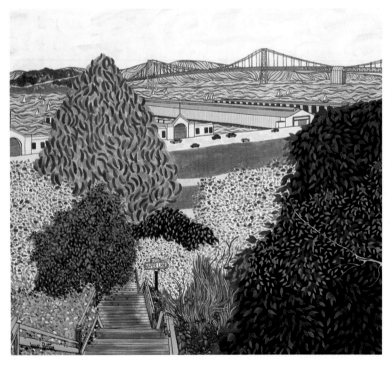

27. Down the Filbert Street Steps on Telegraph Hill with the Bay Bridge and East Bay and Treasure Island in the Background

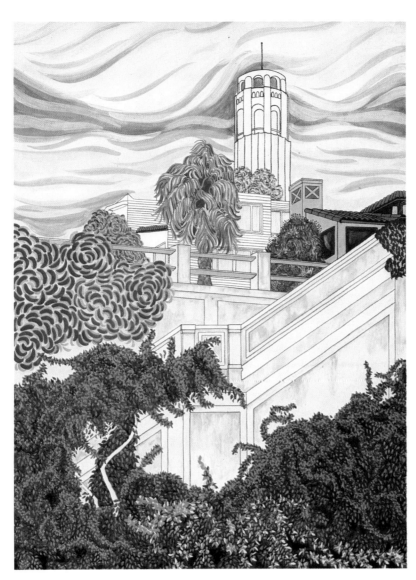

25. Coit Tower from Filbert and Montgomery Streets

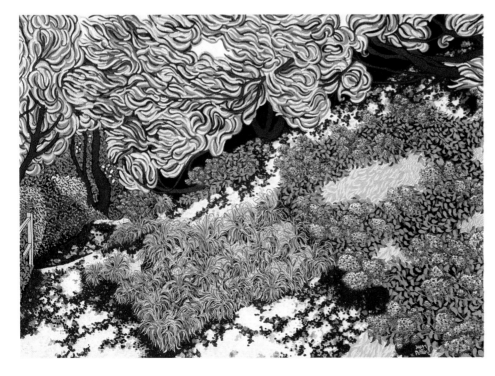

26. Downhill Natural Growth Below Coit Tower near the Cliff Edge

28. Telegraph Hill Rooftops Looking Toward Coit Tower from Green Street

30. Night Scene on Broadway from the Corner of Kearny and Broadway

29. City Lights Books at 261 Columbus Avenue

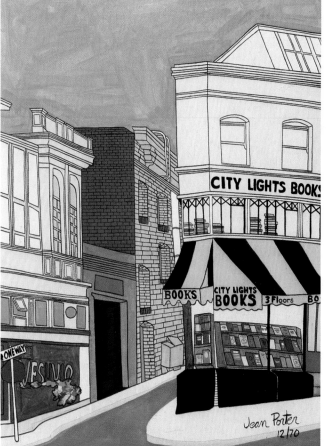

31. Napoli Market at 1756 Stockton Street near Washington Square

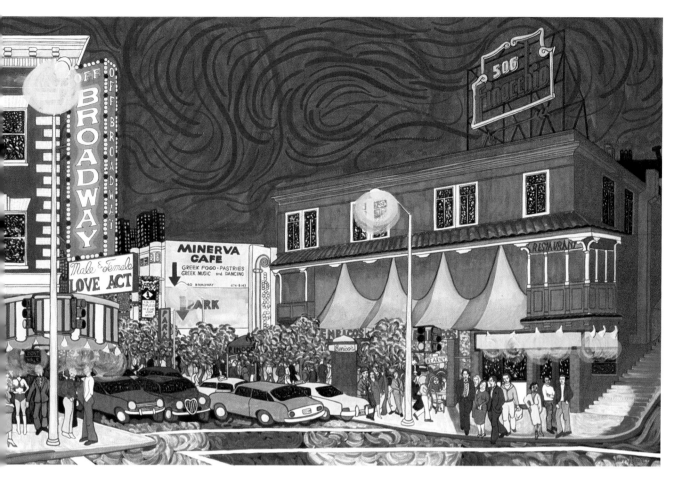

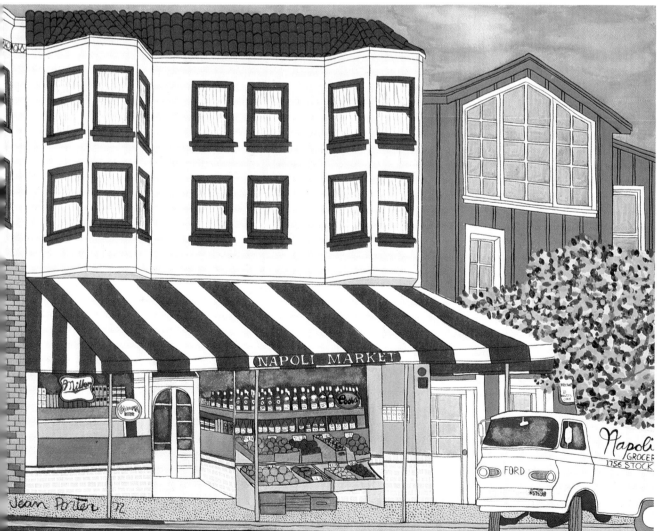

CHINATOWN

When the cry "Gold in California" echoed around the world in 1848, San Francisco was a tiny village near the Spanish fort called the Presidio, with a population of 767, including 1 Chinese. The center of the village was Portsmouth Square, then only a block above a small, sheltered cove that lay between Telegraph Hill and Rincon Hill called North Beach. Ships lay at anchor 1,000 feet offshore in the deep water and loaded their cargo aboard barges that were rowed up on the beach. From there the cargo was carried up to dry land in Portsmouth Square and sold.

The first year after the gold strike, over 20,000 fortune seekers landed in San Francisco and rushed pell-mell to the foothills and mountains of the Sierras. The crews that brought them deserted their ships; merchants and clerks abandoned the stores in the square; tradesmen and workers left their jobs in the Presidio nearby and raced after them to the gold fields.

Among the first 20,000 immigrants there were over 700 Chinese. Most of them did not go to the diggings in the mountains. They came with some means and set up shops about the square, first along Sacramento Street, then down Dupont (now Grant) Avenue, and Kearny Street. Within a year the shops had spread to Jackson Street and up the hill to Stockton Street. To this day Sacramento Street is called Tong Yan Gai, China Street, by the older Chinese. Within two years the settlement covered six square blocks and formed a bustling, thriving market center. It contained a newspaper, a school, a joss house for worship, and shops of all kinds. There were thirty-three merchandise shops, fifteen apothecaries, herbalists, silversmiths, boardinghouses, a bathhouse, and restaurants.

Beginning in 1850, two years following the strike, Chinese workers began to arrive in great numbers. Each year for the next twenty years from 3,000 to 8,000 were brought from China. A few were able to pay their own passage, but the rest came as contract workers to work for one dollar a day in the gold fields. When the mines started to close, the men hired on to build the railroads; then they drifted into the great valleys where they cleared the forests and swamps, and built the towns and farms. Many were skilled farmers and carpenters.

By 1870 the Chinese population in all of California had reached 123,000. Soon the mines became spent, the railroads built, and the San Joaquin Valley was covered with great flourishing farms. The Chinese workers began the drift to the towns and cities, and San Francisco's Chinatown became the vortex in the searchings of the great army of workers. The population of Chinatown had swelled to 40,000. It was now a city within a city in the heart of San Francisco with a burgeoning population of almost 200,000. Cut off from the main part of the United States by 1,000 miles of dangerous wilderness, with only the flimsiest attempt at law enforcement, San Francisco became known as the most violent port in the world.

In order to gather strength to cope with the problems of isolation in the strange turbulent land, the people of Chinatown created the tongs and the benevolent associations, organizational forms that are unique to the Chinese in America. The benevolent associations were either district councils formed by people from a single region in China, or family councils that were formed by people with a common surname.

The Chinese Six Companies, formed in the early 1850s, is an affiliation of six district councils. The union created an organization powerful enough to deal with the white community and to cope with the social problems the Chinese faced within their own community. They organized a Chinese school that exists to this day on the top floor of the Six Companies building on Stockton Street (fig. 32). Until 1878, when an envoy was sent from China, they acted as an unofficial liaison with the Chinese government. They raised funds for endless causes and struggled for the recognition of the civil rights of the Chinese. Eventually the Six Companies became a powerful political force.

The word *tong* means "association." Fraternal tongs were formed by people who had neither a common surname nor a common region of origin that would permit membership in the benevolent associations. They were a gathering together of people into fraternal societies to create a common bond such as the Elks, Moose, or Odd Fellows. Other tongs were formed by members of a business (laundrymen) or a craft (restaurant workers or carpenters).

The "fighting tongs," however, were something terrifyingly different. They were organizations of men who banded together to gain strength and power, and then used that power to foment and control prostitution, gambling, opium smuggling, slave labor, and blackmail. They preceded and anticipated the methods and organization of Al Capone and the Mafia by over half a century, exploiting every form of vice, protection, and murder.

They gave themselves strange, ironic, and euphonious titles—The Chamber of Higher Justice, The Society of Righteous Brethren, and Hall of Realized Repose—but regardless of their flowery titles, they were indeed brazen and hardened murderers.

In 1877 a depression brought strikes, bank failures, and unemployment. The Chinese found it in-

creasingly difficult to find work in which they did not have to compete with white workers and came to depend more and more on work in laundries, in restaurants, and as domestics. The Chinese laundry is perhaps no longer the universal activity and symbol it once was, but the restaurants have flourished. There are now in Chinatown about sixty restaurants. The serving of food has become the second largest employment of Chinese labor in Chinatown, second only to the garment shops. The genius of the Chinese in the culinary arts is legendary. At one time in the 1920s and 1930s almost all the large hotel kitchens in San Francisco were run by Chinese.

The first Chinese restaurants appeared immediately with the army of gold seekers. A hilarious account in "Chinese in California" by the Chinese Historical Society tells of the early miners crowding into the Chinese restaurants. The waiters could speak no English and the miners no Chinese. Whatever platters of steaming food were served was left to the discretion of the waiter, and no way existed for the patron to explain his pleasure or dissatisfaction or to reorder the same dish on another day!

For decades following the end of the Gold Rush, the restaurants almost exclusively served Chinese patrons. Until the 1930s the white population knew very little of the endless variety of titillating dishes the Chinese prepared. A writer on San Francisco restaurants observed in 1868, after a rare excursion into Chinatown, "The Chinese restaurants are constantly alight with festivities and banquets and one should not overlook Chinese restaurants on their gourmet's tour." Banquets were held to which Occidentals were rarely invited. These banquets were in three phases, each one-half-hour long, during which twelve to twenty separate dishes were served with leisurely intervals between each phase while the diners adjourned to sitting rooms to talk and smoke.

Not only did the non-Chinese remain relatively unfamiliar with the delights of Chinese cooking, he was almost totally ignorant of Chinese teahouses, where lunch and leisurely Sunday brunches were served. The patrons sipped tea and indulged in a great variety of a la carte dishes called *dim sum*, delicate pastries stuffed with pork, mushrooms, shrimp, and all sorts of delicious seasonings; steamed buns of rice flour filled with lotus seed or sweets, and many other exotic spices and flavors.

The dishes ordered in Chinese restaurants by San Franciscans were almost exclusively chop suey or chow mein. The Chinese Historical Society states that chop suey (not a Chinese dish) was created during a banquet for Li Hung-chang in 1878. Li Hung-chang was the first Chinese viceroy to visit San Francisco.

At the lavish dinner attended by Adolph Sutro, the mayor, and many important businessmen, the Honorable Mr. Li whispered to the waiter that he wished a simple dish of vegetables and a little meat. The waiter rushed out to the kitchen, and soon came back with a dish that the Honorable Mr. Li said was a *chop suey*, the words meaning a "potpourri" or miscellany. The dish caught on, chop-suey houses sprang up all over the country, and with them many different stories of the origin of chop suey.

Many years passed before appreciation of the Chinese culinary arts developed. Chinese cooks began to combine American dishes with the traditional way of cooking—fried rice, egg rolls, fried noodles, sweet and sour ribs, lamb, and beef. Lamb and beef were unknown as foods in China because both animals were considered too valuable to eat.

Finally, after World War II, large, well-lighted restaurants were built that catered largely to a non-Chinese clientele. Johnny Kan's is perhaps the most famous (fig. 33). Celebrities dine there night after night. The Golden Dragon is a late-night restaurant next to the Universal Café, where after-theatre patrons and street people crowd in. The many fine restaurants, each with specialties of the house, are the subject of arguments among the local people, who debate their merits with a sense of loyalty that would be a credit to a party fund raiser.

Sam Wo's is a great favorite. It is twelve feet wide and three tiny stories high. The diner enters through the kitchen and mounts the narrow stairs to the rooms above, which are connected to the kitchen by a dumbwaiter. There is a constant hubbub pierced by the waiters screaming orders down the shaft of the dumbwaiter. It is one of the two restaurants in all of Chinatown that serves raw fish salad, an unforgettable dish of marinated fish, spices, and pickled fruits that give it a perfumelike flavor. The other favorite of Sam Wo's is *jook*, a rich rice gruel reputed to cure hangovers.

For European service, the Imperial Palace and Empress of China on Grant Avenue and the Celadon on Clay and Stockton streets are elegant and popular, where Occidentals can be seen proudly struggling with chopsticks and the Oriental diners disdainfully eating with forks.

San Franciscans pride themselves on their knowledge of the lengthy menu, even daring to discuss with waiters the Chinese Menu, a separate menu written with a calligraphy brush in Chinese characters and containing many esoteric dishes that the chef thinks may not be popular with the non-Chinese diner.

Chinatown, with a population of 40,000, that has been constant for almost 100 years, is the largest set-

tlement of Chinese outside of mainland China and has become the center of Chinese-American society and culture. The Six Companies remains the most powerful single organization. The architecture of the association building on Stockton Street as well as that of the Hip Sen Benevolent Association building above the Universal Café (fig. 34) is of a classic design synthesized in this country. The ornamental components of the dragon, the brightly colored facade, and the pagoda roof with its curved eaves are traditional and symbolic. The curved roof is designed to prevent the intrusion of evil spirits, which, if they attempted to gain access over the tiled roof, would be projected up into the sky by the curve. The golden dragons seen on the curving outriggers of some of the pagodas and spiraling about red, exterior columns are meant as protection against evil. The strange-looking dogs sometimes seen crouching in the doorways with a large ball between their paws are a symbol of strength.

The flavor of Chinatown that is now so valued by San Franciscans depends less on the indigenous architectural style than on the colorful lives of the people. At five o'clock in the early foggy morning the trucks from truck farms in the East Bay and Petaluma arrive with fruit, vegetables, chickens, ducks, meat, and fish. By eight o'clock the street has already become crowded with shoppers. The fruits and vegetables are piled high on the bins of the open stalls (fig. 35). Meat and fish markets display live frogs, shellfish, fish, steaming ducks, pork ribs, noodle dishes, and combination dishes "to go." All day long until late in the evening the streets throng with men, women, and children. Chinatown is the shopping center for the Chinese of the entire northern half of California.

The most important tourist attraction in the city, and the neighborhood most visited by San Franciscans is Chinatown. As many as 200,000 spectators, San Franciscans and visitors from all parts of the world, line the streets to watch the annual Chinese New Year's Parade. The non-Chinese call out "Gung Hay Fat Choy"—Happy New Year—and pride themselves on knowing the symbol of the new year. There are twelve symbols just as there are twelve signs of the zodiac. Each year is named for an animal, such as the year of the rat, followed by the year of the ox, tiger, hare, dragon, serpent, horse, ram, monkey, cock, dog, and boar. If asked the year of his birth, a Chinese will often answer by naming the symbol of that year. Each animal has its characteristics, just as do the astrological signs, and there may ensue serious discussion about the advisability of a girl born in the year of the tiger marrying a boy born in the year of the horse. All of the animals in the series earn their special place by their ability and courage in devouring evil spirits.

New Year's festivals last a month. It is a time for cleansing both spiritually and literally; a time for paying all bills; a time for reckoning all accounts, remedying ills, and a time for charity. Dust is cleaned from every corner of the house to make certain no evil spirits lurk who will stay on into the new year. Night after night, fireworks crackle and explode announcing the departure of the gods that have guarded the house all year, and now leave to make their report in heaven. Friends greet each other over and over on the street. Red streamers are attached to the doors with epigrams, predictions, and slogans: "May this house be free from tigers," "May wealth and glory be yours" (perhaps the origin of the practice of putting such slogans and aphorisms in fortune cookies).

New Year's Day is traditionally the second full moon after the night of the winter solstice. When New Year's Eve arrives after the month of preparation, there is great excitement. Darkness falls; then the glorious parade begins. A great 200-foot-long dragon sweeps along, his magnificent fire-snorting head tossing and feinting at the crowd, his great fangs gleaming, the golden horns sparkling, and all the while firecrackers burst at his fifty pairs of feet. Behind come the floats with the beauty queen and her entourage, then the floats of the societies, the tongs, the war veterans, schoolchildren marching, the great lions charging about, the drum and bugle corps of the schools, organizations of all sorts, and all this followed by limousines bearing politicians, Occidental and Chinese, until nothing remains but the crackling fireworks. On the balconies above Grant Avenue, crowding into the restaurant windows, leaning from rooftops, are the grandchildren and great-grandchildren of the men who came with the Gold Rush, the magnificent survivors who gave so much to the building of the West.

Chinatown was created in thirty short years one hundred years ago. It is changing as rapidly as it began. The present generation, now employed in every trade and business, is leaving to live in the residential neighborhoods and the suburbs. Supermarkets in San Francisco, Marin County, and the peninsula south of the city have a section for imported Chinese food, as well as Chinese vegetables and bean cakes in the produce departments. Although it remains and will remain, the cultural center of Chinese America with its schools, museums, theatres, churches, library, and the Chinese Culture Center, perhaps it will one day be principally a place of historical interest.

32. Chinese Six Companies at 843 Stockton Street

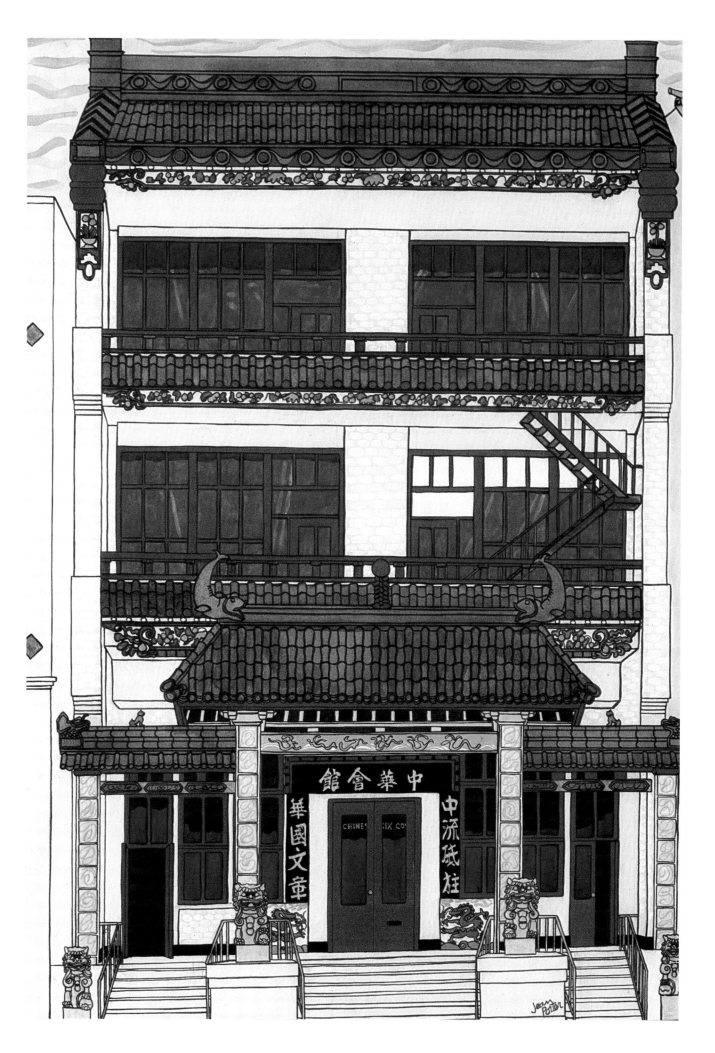

中華會館

中國文章 中流砥柱

CHINES...IX CO...

Jean
Potter

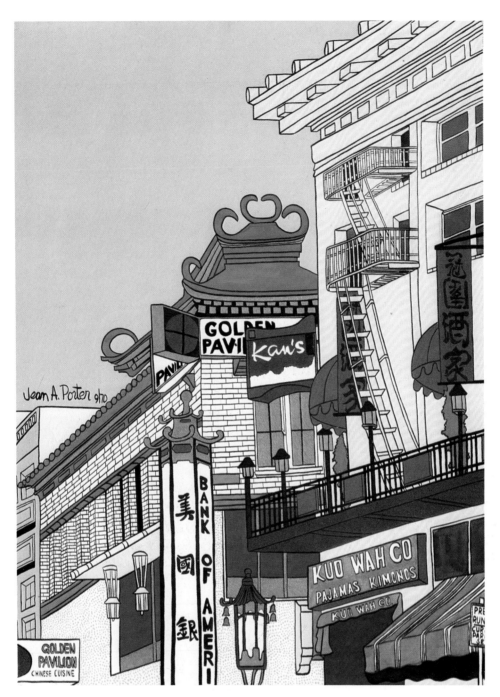

33. Kan's Restaurant at 708 Grant Avenue

34. Chinatown Restaurants on Washington Street from Waverly Place

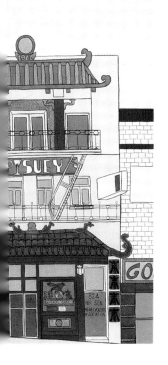

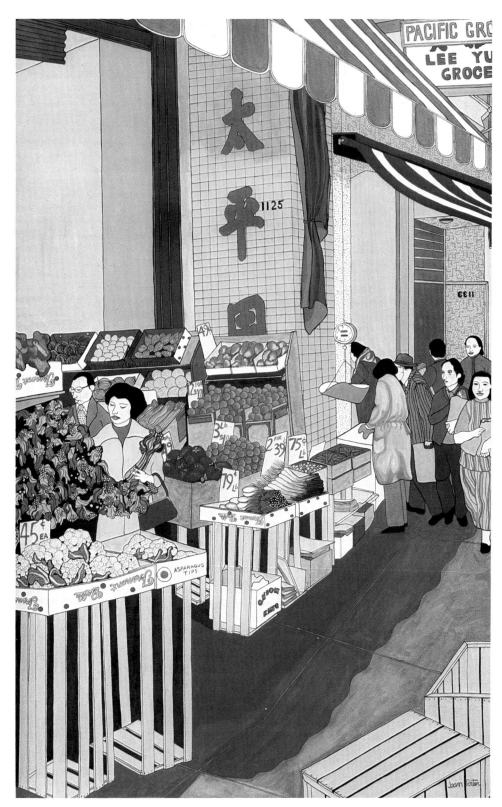

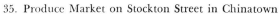
35. Produce Market on Stockton Street in Chinatown

NOB HILL

Once the very exclusive purlieu of the railroad barons and the kings of the Comstock Lode, it is often theorized that the name Nob Hill derives from *nabob* or *snob*, but the shape of the hill itself is almost a perfect knob with a single square block forming the top—Taylor, Mason, and California streets to Sacramento Street.

Unlike Telegraph Hill and Russian Hill, which were first settled by the poor and the artists who were willing to climb its slopes and claim a site very few desired, Nob Hill was settled from the very first by the rich and powerful. In 1856 Dr. Arthur Hayne cut his way through the thick underbrush to the very summit where the Fairmont Hotel now stands and built a house of adobe and wood, hauling the building materials on mules. Others soon followed but were content to build on the lower slopes. It was not until the introduction of the cable car in 1873 by Andrew S. Hallidie, the inventor, that the hill became attractive to the men who controlled much of the destiny of the city and state.

The first of the regal residences was built by David Colton, followed by Leland Stanford, Charles Crocker, and Mark Hopkins, three of the railroad's "Big Four," then James Flood and James Fair, two of the great silver kings of the Comstock Lode. It was as if the steep knob was a citadel, and there on the very top they built their gaudy palaces laden with spires, cupolas, arches, and endless ornamentation like the Bavarian mountaintop castles of Ludwig II. Willis Polk, the most successful architect of the day, who later designed the Hallidie Building on Sutter Street, remarked that the palaces had one thing in common: they represented great unbridled wealth.

Strangest of all was the Mark Hopkins residence set on the edge of the hill above the Stanford residence. Seven architects worked on it at one time, and the result resembled a medieval castle. It is ironic because Mark Hopkins was a simple, modest man who for years lived at the bottom of the hill in a thirty-five-dollar-a-month cottage. Oscar Lewis describes him as "an unextravagant rich man. . . . But the most modest and kindly . . . with none of the vanity and ruthlessness of his partners." He was content with his cottage, but after Stanford built his residence, Hopkins's wife, Mary, weary of the penny-pinching expenditures extracted from his $20 million, insisted on a grand residence. He allowed her wish and gave her complete authority for its fulfillment. He never lived in the palace. He died in 1878, a year before it was finished. Mary Hopkins lived there only a few years and then she moved east, and the house was eventually given to the University of California, which established there the California School of Fine Arts. It was destroyed in the fire.

The Mark Hopkins hotel was built in 1925 at a cost of $2.5 million. Its simple restrained brick facade and tasteful marble entry are in striking contrast to the original ostentatious structure (fig. 36). The Top of the Mark is no doubt the most famous of the city's rooftop salons and restaurants. Poised as it is atop the very pinnacle of the city, it has become a symbol of distinctive hospitality. "Meet me at the Mark" is an invitation known the world over.

One of the most tasteful of the hilltop residences was that of David Colton, a skilled politician and lobbyist who became a fast friend of his neighbor, Charles Crocker. He joined the railroad barons but later had a falling out. After his death the residence was sold to Collis Huntington. Finally, all of the Big Four lived on the hill. It was a very popular Sunday excursion to take the cable car up the hill and ride slowly past the great gray mansions and bask in the reflected glory of the hilltop giants, for to the general populace the glittering palaces connoted the city's power and authority.

The Huntington mansion, too, was destroyed in the fire. The site was given to the city, and was later dedicated as Huntington Park (fig. 37).

The Pacific Union Club, adjoining the park, occupies the former Flood mansion, the only hilltop residence to survive the fire. James Flood, a former miner, opened a popular saloon called the Auction Lunch where, by eavesdropping and judging the importance of the conversations he overheard among the high-rolling diners, he was able to invest very successfully in stocks. Later he joined with William O'Brien, John Mackay, and James Fair who by extremely clever dealings had gained control of two of the richest mines in the Comstock Lode.

Across from the Flood mansion James Fair began the construction of his residence, but his unhappy homelife led him to abandon the plan when only the foundation was laid. After he died in 1894, his daughter decided to build a deluxe hotel on the foundation. It was complete except for the furnishings, which were already in the building when the earthquake struck and fire swept the hill, gutting the structure and leaving only the walls. One year later, under the supervision of Stanford White, it was again completed and opened its doors to a gala celebration. The Fairmont Hotel became at once the center of the city's social activities and to this day its grand lobby with its red Victorian furnishings and tall white marble pillars is a favorite meeting place of both travelers and residents (fig. 38).

Facing the Fairmont, on the opposite side of the hilltop rising above the park and the club, is the impressive Grace Cathedral built on the site of the razed Crocker estate. The original Grace Cathedral, on Powell and John streets, was the first Episcopalian cathedral in California. After being destroyed by the fire, it was rebuilt on the present site, which was donated by the Crocker family. Begun in 1910, it was under construction for almost sixty years; now complete, its spire and cross rise 270 feet above the hilltop.

Across California Street is the Huntington Hotel, one of the most prestigious and also the most gracious in San Francisco. Down the street and over the crest of the hill, the Stanford residence became the site of the Stanford Court, which was completely remodeled and refurbished in the 1970s into one of the city's many very attractive hotels.

Today the hilltop is one of the most pleasant areas in the city. The soaring cathedral, the lofty fashionable hotels and apartment houses, the exclusive club, and the tiny park hidden behind the shrubbery barely suggest the turbulent times and the epic struggles for power that shaped and created the city and the West.

36. The Mark Hopkins Hotel at California and Mason Streets

37. Huntington Park and the Pacific Union Club on Nob Hill

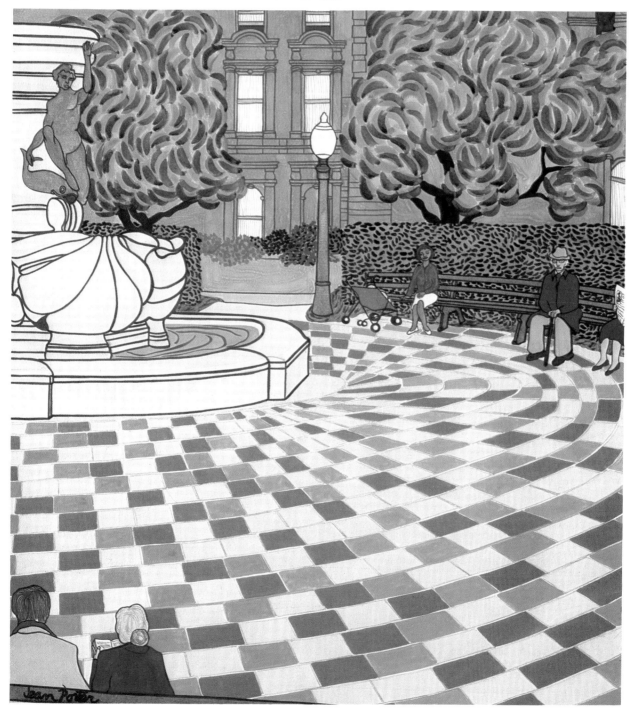

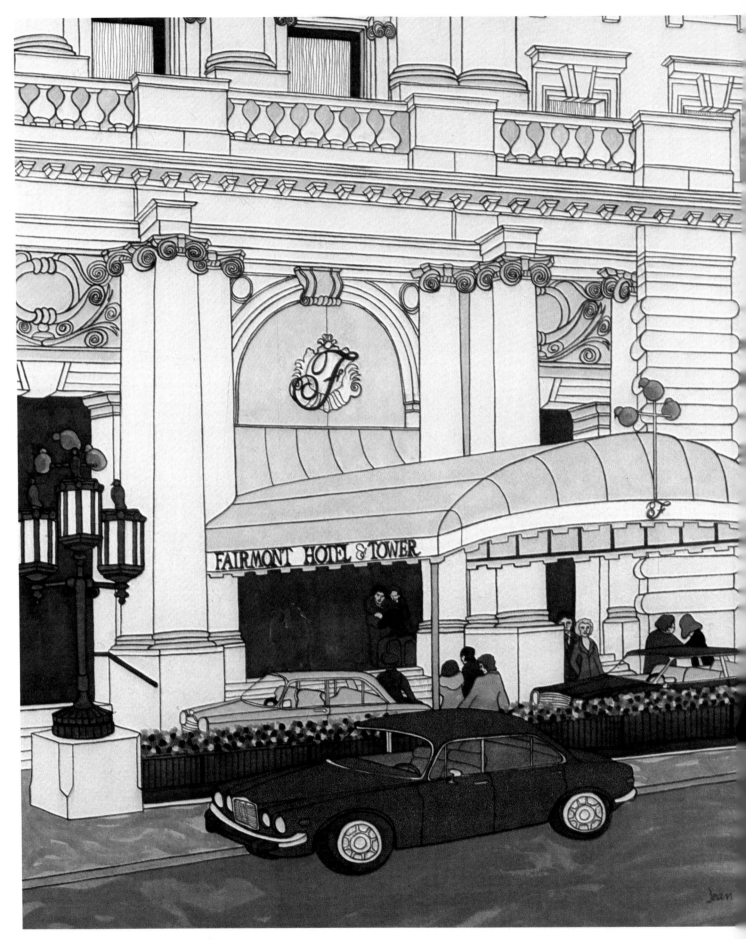

38. The Fairmont Hotel on Mason Street

THE BAY TO THE BREAKERS

During World War II San Francisco was known among servicemen and merchant seamen as the "best liberty port outside of New York City—a city that has everything." That may be an unreasonable exaggeration, but it can be said that almost every form of spectator and participatory sport and activity is available for the amusement of the traveler or native. There are professional teams in every major sport, two racetracks—Bay Meadows and Golden Gate Fields (fig. 39)—the busy performing arts, galleries, museums, it is all there. But the most popular attraction of all is the city itself. Hundreds of thousands gather every year at Vista Point at the north end of the Golden Gate Bridge, or atop Wolfback Ridge on the Marin Headlands (fig. 40), to watch the summer fog billow through the gate, over the hills, and above the city, or to catch the sun as it sets beyond the sea, the white city absorbing the colors of evening.

There are over forty hills in the city, and from each hill the view is as new and different as the shifting patterns of a kaleidoscope. One of the most beautiful bicycle rides, hikes, jogs, or drives is from the Embarcadero to the Pacific Ocean, along the waterfront past Fisherman's Wharf, Aquatic Park, the Marina, up over Russian Hill and Pacific Heights while enjoying a great variety of residential styles from simple cottages to elegant Victorians and striking "moderns." The red cottage (fig. 41) is at the end of Green Street just before the entrance to the Presidio. It is one of the oldest houses in Cow Hollow. The blue Victorian on Larkin near Greenwich Street on Russian Hill (fig. 42) is a classic example of its style.

Follow Lincoln Boulevard into El Camino del Mar through the Presidio by Baker Beach (fig. 43), and Lincoln Park past the Lincoln Park Golf Course (fig. 44) and the Palace of the Legion of Honor, down Point Lobos Avenue to Sutro Heights (fig. 45) above the Pacific, the Cliff House, and Seal Rock. All that remains of Sutro Heights are the grounds, which are now a small park. When one first wanders into the almost hidden retreat, it is as if the twentieth century is left behind and one has entered an ancient garden in a time machine.

Adolph Sutro's great mansion once stood there. He was an immigrant mining engineer who made millions by executing a brilliant engineering feat. He drove a tunnel beneath the Comstock Lode, which drained the drifts and allowed the miners to reach the rich veins that could not otherwise have been reached by the mining methods of that day. In 1863 Sutro built the Cliff House above Seal Rock. It at once became a favorite resort for the elite. Twice it burned to the ground and once was almost blown to the ground when a foundering freighter, loaded with forty tons of dynamite, pounded by heavy surf exploded just below the Cliff House. Adolph Sutro acquired large areas of land along the oceanfront and as far up as 35th Avenue, planned the boulevard system that now exists, and the use of much of the land including Lincoln Park.

The Great Highway was built in 1927 and stretches along the ocean for three miles (fig. 46). The position next to the Cliff House, from which the painting was created, is a dramatic site from which one can watch the surf, the crowds of bathers on bright warm days, or the raging storms that howl in from the sea.

The Great Highway and Esplanade, the widest boulevard in the United States, extends to the Fleishhacker Playfield and Zoological Gardens. The recreational complex includes playgrounds, a merry-go-round, a great swimming pool that is 1,000 feet long and 150 feet wide. Next to the playground is the Fleishhacker Zoo built by WPA labor in the 1930s. It was designed along the lines of the world-famous Hagenbeck Garden in Stellingen, Hamburg, Germany, and simulates the "natural" environment of the animals who are protected and restrained by moats and rock walls. The Monkey Island, the preening peacocks, the stately, aloof llamas (fig. 47), the mocking chimpanzees and orangutans (fig. 48), and the great pool of cavorting seals are favorites of the endless crowds of children and adults.

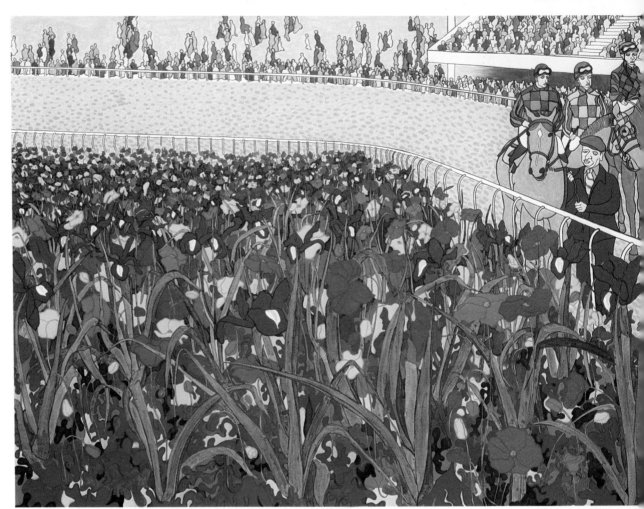

41. House on Green Street

39. Racing at Golden Gate Fields

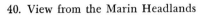

40. View from the Marin Headlands

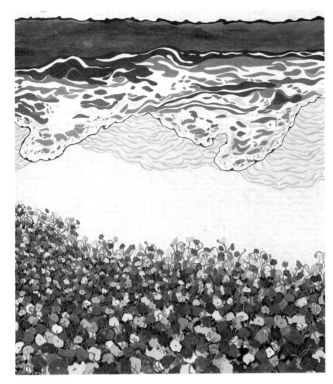

43. Baker Beach in the Presidio

44. Lincoln Park Municipal Golf Course

42. Russian Hill Victorian

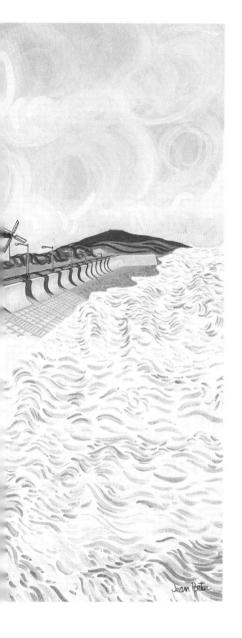

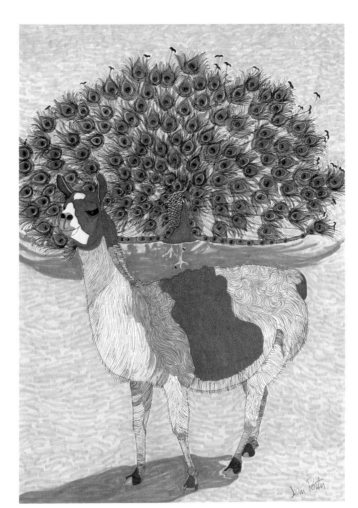

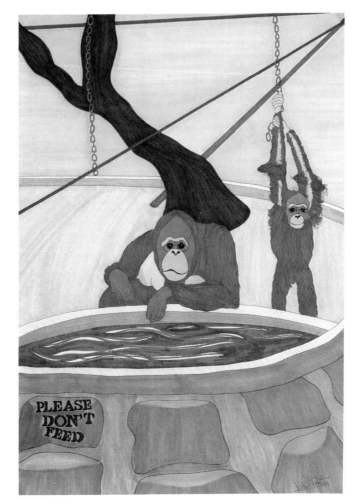

GOLDEN GATE PARK

In 1870, when the ambitious city fathers committed San Francisco to the purchase of 1,000 acres in the western part of town with the idea of converting it into a great park, there was a chorus of protest from economy-minded citizens. What a folly to spend nearly a million dollars where nothing can grow.

The protests were overridden, although not silenced, and a Park Commission was appointed. A wise first decision was the hiring of the young engineer, William H. Hall, to survey the territory and to draw up a plan for its development. Hall finished his maps in February 1871. He found 270 acres of good arable land in the eastern part of the park, but the remaining 730 acres were bare sand. Everything west of Strawberry Hill was shifting dunes, except for the fringes of seven or eight small ponds where a few score willows and lupines had established a foothold. But he was confident that the sand could be secured by proper planting and by importing topsoil. He claimed that a forest might eventually rise on the wasteland, but the park's critics remained bitter and skeptical.

The issue of the dunes was not to be decided for some decades. Hall devoted his early attention to the arable 270 acres in the east. It was here the greatest change could be effected in the shortest time and for the least cost. Meadows were seeded and nurtured, a large nursery established, avenues laid out, and decorative shrubs encouraged. The scrubby oaks and *Ceanothus* were augmented and then replaced by trees of a more attractive aspect, although not all are as prepossessing as the flowering cherry (fig. 49).

Soon San Franciscans began to take pride in their 1,000-acre "folly." At the end of 1877 the park received its first big gift—a number of crates containing the prefabricated Conservatory, which still stands to receive thousands of visitors every month. Figures 50 and 51 give a good sense of the interior of the Conservatory's central room.

The Conservatory was not originally intended for San Francisco at all but for the San Jose estate of James Lick, a real estate millionaire and an ardent horticulturist. He ordered it in 1875 from England, specifying that it be patterned after Queen Victoria's conservatory in Kew Gardens. It was shipped around the Horn, by the time it arrived, Lick had fallen ill. It was still in its crates when he died in October 1876 at the age of eighty. The Society of California Pioneers, of which Lick had been president, inherited it and donated it to the park. The glazers troweled out more than three tons of putty to secure its thirty-three tons of glass before the plants were carried in and the doors opened to the public in 1879.

Meanwhile, the eastern part of the park was taking shape. In 1878 the artist C. P. Parsons drew a careful bird's-eye view of the city from the top of Yerba Buena Island, now the midpoint of the San Francisco–Oakland Bay Bridge. The park is in the background with only scattered houses surrounding it. The park's hills are shaded by darkness that implies vegetation and its wide, macadamized avenues are clearly indicated.

Accounts of the day show that very soon the park began to receive heavy use. The avenues especially were a delight to the rich young men of the city, for there was no finer place to race a team of horses. As early as 1875 a speed limit of ten miles per hour was established by statute, and throughout the century speeding accounted for nearly half the arrests made in the park.

In 1887 a forty-one-year-old gardener named John McLaren came to work as an assistant. He soon was promoted to full superintendent. It is not unusual for a man in his forties to undertake the major work of his life, but it is most unusual for him to be working and improving some fifty years later. Sophocles was such a man. John McLaren was another. Golden Gate Park was his to nurture until his death at the age of ninety-six.

McLaren had the patience of a medieval cathedral builder combined with a grim practicality. When a city official asked him to suggest a fitting monument for his ninetieth birthday, he said, "ten thousand yards of good manure."

It was McLaren who laid siege to the shifting dunes. Experiments showed that the bent sea grasses from Holland (*Arenaria ammophila*) were the best first weapon of attack. In the colorful prose of the report of 1889, they "prepare the way for a promiscuous planting of the lupin." Grass and lupine secured the soil and extracted salt, making it possible to set out hearty pines and eventually bedding plants and meadow grasses. Today, the forest is so firmly established that it requires effort to stand beneath it and conjure up the dunes of a mere century ago.

Golden Gate Park's creation is a model of urban ecological adaptation. The principles of recycling were used from the outset. Until the automobile displaced the horse, the city's street sweepings were brought out to the park to add their increment to the soil. When foundations in the western part of the city were dug, the excavated earth was carted to the park to provide a cover of topsoil for the sand.

The heart of the park's water system also became one of its scenic centers. Stow Lake was scooped out around the base of Strawberry Hill. The sandy soil

would not hold water, so the reservoir was lined with ten inches of clay. Even the 1906 earthquake was unable to crack the lining. With its boating concession, abundant fowl, and the beautiful, but now defunct, waterfall cascading down Strawberry Hill from the holding reservoir on top as it aerated the ground water, Stow Lake was one of McLaren's happy marriages of practicality and aesthetics (fig. 52).

In 1902 and 1905 two great windmills were erected near the ocean—the Dutch and the Murphy Windmills. The Murphy Windmill was one of the world's largest with sail-type spars measuring 114 feet from tip to tip. They were originally constructed to pump water for irrigation and in a fifteen-knot breeze, the Murphy Windmill was able to pump 40,000 gallons of water an hour. However, the tremendous seaborne storms slowly tore the spars to shreds, and in 1927 electrically driven pumps were placed in the structure. In 1980 the Dutch Windmill was refurbished and its sails rebuilt. They will once again revolve majestically but will no longer pump water.

McLaren, who intensely disliked statues and buildings, did have to accommodate himself to two large and often expanding structures, the M. H. de Young Museum and the California Academy of Sciences, which draw millions of visitors each year. They flank the large, open-air Music Concourse with its benches and plane trees (figs. 53 and 54). The paintings show the concourse in two of its pensive moods, but on Sundays thousands of people come to hear the rousing band music in the European manner, and it takes on a joyous festive air.

McLaren seems to have loved all trees and shrubs, but rhododendrons were especially dear to him, and every acre gained for the forest provided new settings for these shrubs. By 1894 he had increased the number of varieties in the park from 7 to 44. The catalogue included in the report for 1912 lists 85 species and the report for 1924 more than 170 species and hybrids. They are to be found in every sector of the park, bringing brilliant color to the fog-shrouded summers.

Although its name derives from the Greek words for rose and for tree, the rhododendron is neither. True roses do not take well to most of the park's soil and climate. It was not until 1961 that the San Francisco Chapter of the American Rose Society chose the site of today's Rose Garden as the place to test new varieties in San Francisco's cool weather. The three paintings of the Rose Garden suggest a silent and timeless mystery that belies both the youthfulness of the project and the often bustling activity among the sixty-three beds as local rosarians pursue their genteel passion (figs. 55, 56, and 57).

One of America's greatest urban parks did not come easily. The monumental patience of its creators, Hall and McLaren, is surely as authentic a part of our state's heritage as the Gold Rush.

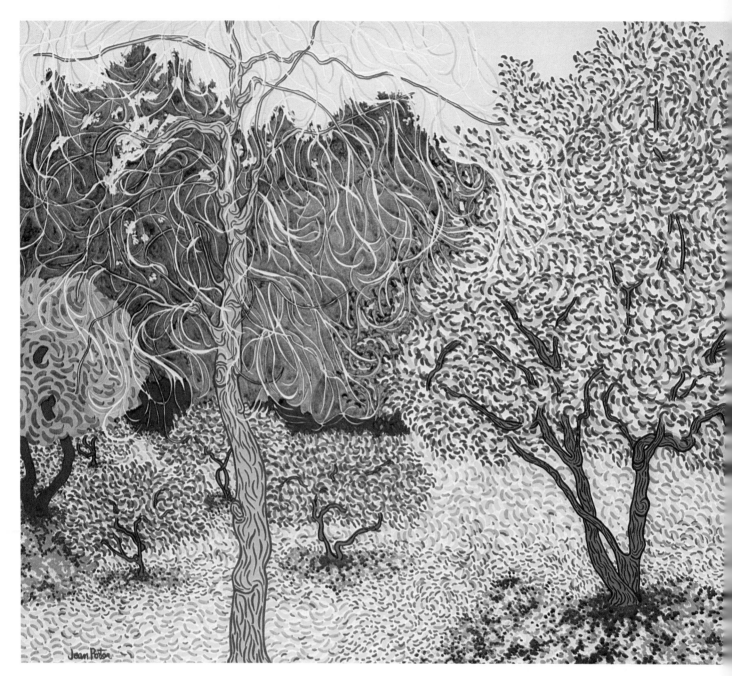

49. The Cherry Trees Beginning to Bloom in Golden Gate Park

50. Inside the Conservatory at Golden Gate Park

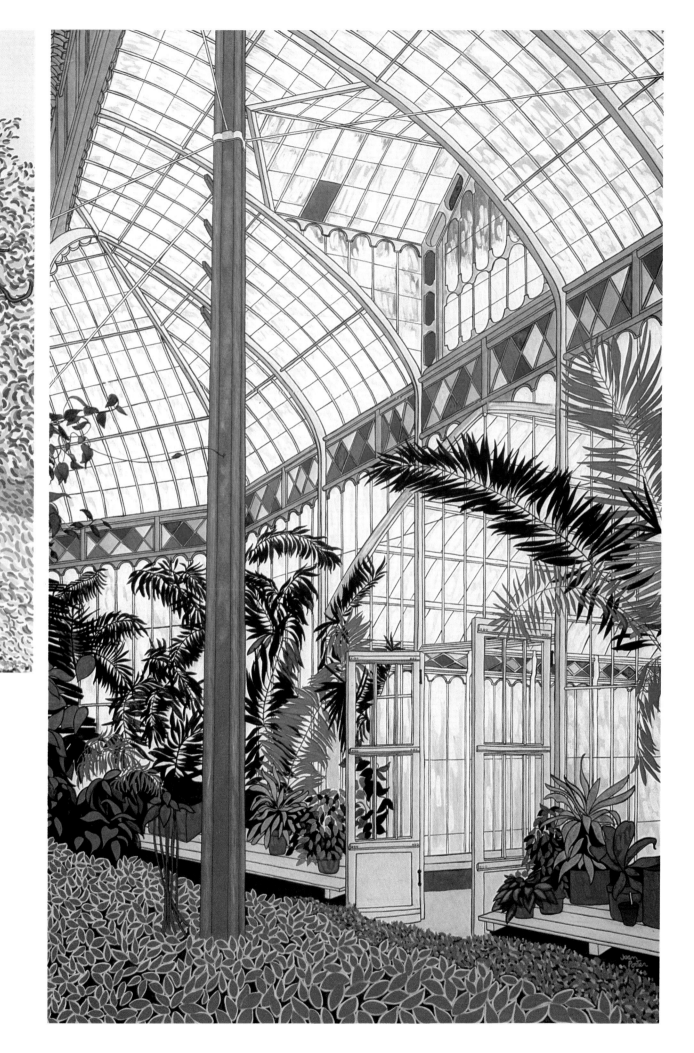

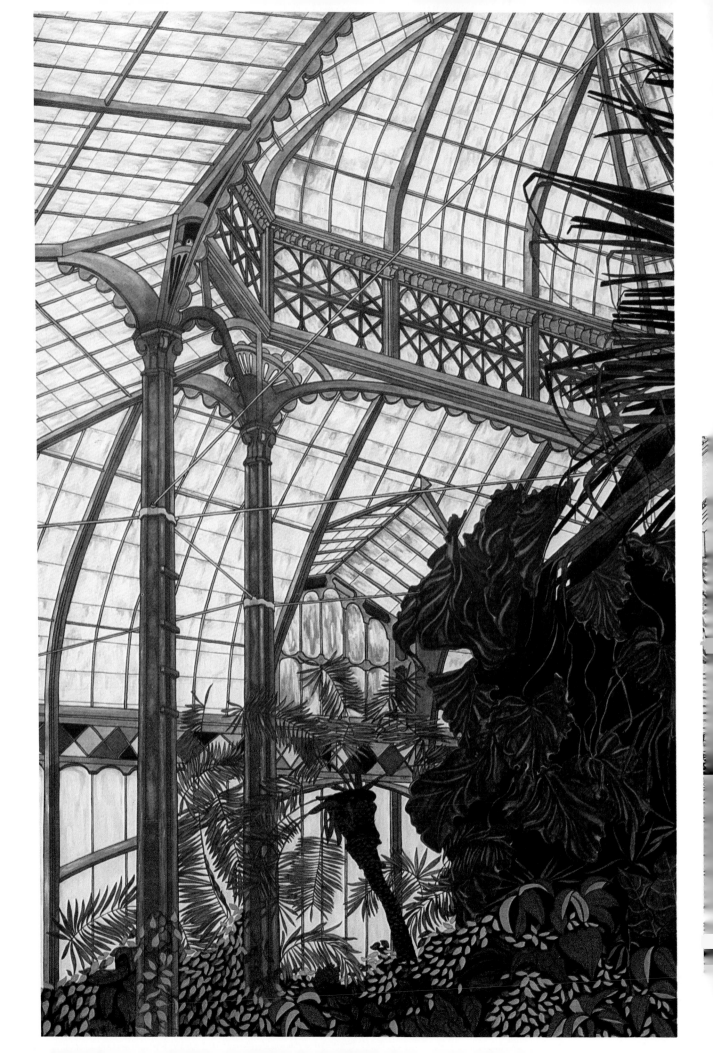

51. Another View Inside the Conservatory

52. Stow Lake at the Base of Strawberry Hill in the Park

53. Golden Gate Park's Open-Air Music Concourse

54. At the Music Concourse near Steinhart Aquarium

55. The Rose Garden at Golden Gate Park

56. Another View of the Rose Garden

57. Tree Roses in the Garden

THE PERFORMING ARTS

With a population that has never exceeded 750,000, San Francisco is second only to New York in the number of its performing arts groups. The San Francisco Ballet was the first civic ballet in the country; it was the first city to build its own opera house; and the first to support its performing artists with public funds. There are four major performing companies: The San Francisco Ballet, The San Francisco Opera, The San Francisco Symphony, and the American Conservatory Theatre (A.C.T.), as well as scores of drama, music, and dance groups that perform throughout the city. If to this picture is added the almost 300 bookstores and a like number of art galleries, it is not boastful for San Franciscans to claim a very proud tradition in the arts.

It is especially remarkable when the brawling scene of a century ago is evoked: the bored, aimless crowds parading up and down Montgomery Street and the Barbary Coast, gathering about any street performer; drunken miners paying poor demented Oofty Goofty twenty-five cents for the privilege of smashing his head with a cue stick while the others crowded around in the dark street howling with pleasure. There were almost 600 places that sold whiskey, and every saloon had its gambling tables. Ninety percent of the population was male, and the average age was twenty-five.

Very soon from among the disappointed "argonauts" returning broke from the diggings, entertainers began to appear. Melodeons sprang up presenting variety shows. The saloons offered their own performers. The various ethnic groups formed musical organizations. The German community had three choral societies, the Italians had variety shows that featured opera, comedy, and song. On Sundays crowds visited the Mexican and Spanish quarters in the Mission District, where there was singing and dancing from morning until late at night.

The first presentation of classical music was in 1850 in the Louisiana Saloon, a program of selections on a single trombone. That week *The Alta California* in its critical review of the program admonished the men to "expectorate" their tobacco juice on their own boots and not on the boots of their neighbors.

Onto this scene in 1851 came Tom Maguire, former hackie and saloon keeper, illiterate and brilliant, who was soon presenting variety and freak shows, the circus, drama, and opera. He became one of the greatest impresarios in the history of the country and for eighteen years he staged every form of entertainment.

In 1854 the first in a series of annual symphony concerts was performed with Rudolph Herold conducting. He was followed as director by Gustav

Hinrichs and Fritz Scheel, who later founded the Philadelphia Symphony.

But it was opera that almost immediately captured the city. Johnny Ryan, call boy at the Maguire Opera House, wrote in his journal in the late 1850s, "Opera, opera, opera, everybody wants opera." He complained that the "four hundred" came only to see and be seen, and he told of how Italian fishermen (who knew the entire Italian repertoire) were recruited for the chorus if the company was shorthanded.

Tom Maguire's theatre burned to the ground twice, but he rebuilt and flourished until 1869 when William T. Ralston, founder of The Bank of California, built the ornate California Theatre, for many years the largest in the city. It was the year the transcontinental railroad was completed. Ralston brought the greatest stars by train from the East. Until then, the performers traveled by ship around the Horn, or across the desert by wagon train. Now they all came—the Booths, Maude Adams, John Drew, Ellen Terry, Helen Modjeska, Maurice Barrymore, Henry Irving, Jenny Lind, Sarah Bernhardt, Marie Dressler, and many others whose names are no longer known. San Francisco was the only city outside of New York where they could be assured of long runs. In addition, the wonderful democratic spirit of the city saw them fêted in the drawing rooms as well as on the stage. It quickly became fashionable to support the arts.

This was perhaps the most important development of all, for within this atmosphere of public approval, support, and adulation the various arts grew deep roots. In 1876 "Lucky" Baldwin built his elaborate Baldwin Academy of Music. In 1879 the newly rebuilt Tivoli Theatre became the Tivoli Opera House and presented its first operatic performance, Gilbert and Sullivan's *Trial by Jury*, and for twenty-six years after that presented operatic performances twelve months a year. By the turn of the century, the scintillating variety and quality of the theatrical activity rivaled New York. In 1906 every theatre in the city burned to the ground.

The city was rebuilt so rapidly that five years later the San Francisco Symphony was formed. Before another fifteen years had elapsed, every segment of the performing arts was again bursting with activity and for the next generation the city continued to develop its many art forms.

Today the Performing Arts Center is across from City Hall. There, the War Memorial Opera House is flanked by Herbst Hall in the Veteran's Building, and the Louise M. Davies Symphony Hall (completed

in 1980), the home of the San Francisco Symphony. The orchestra's twenty-six-week season, from mid-September through the end of May, includes stellar artists and conductors. Inaugurated in 1980 by musical director Edo de Waart is a Fall Contemporary Music Series.

The Opera House, San Francisco's largest theatre, is primarily used for the San Francisco Opera season as well as the San Francisco Ballet, and visiting national and international companies, the Joffrey Ballet, the Kirov, American Ballet Theatre, Royal Ballet of England, the Béjart and others.

Founded in 1923 by Gaetano Merola who for ten years had conducted opera and taught music in the North Beach Italian community, the San Francisco Opera has become one of the world's finest and most prestigious companies. Under Kurt Herbert Adler's twenty-eight-year reign as director, who took over following Mr. Merola's death in 1953, it has become an attraction for foreign and United States visitors. The San Francisco Opera has had its entire season broadcast nationally since 1977.

Special aspects are its wig and makeup departments. In 1980 the first twelve candidates were accepted for training in complete wigmaking and all types of stage makeup for ballet, theatre, and, of course, opera. The very individual training program includes six hours a day of classes, five days a week for a year, the opportunity to work in the productions of the opera company, and to assist and watch the professional, company makeup artists (fig. 58).

The San Francisco Ballet is the oldest professional ballet company in the United States. It was founded in 1933 by Adolph Bolm as the San Francisco Opera Ballet to perform within operatic performances. In 1938 it became an independent company staging its own scheduled seasons and tours with Willam Christensen as director. In 1978 the company performed its first New York season in many years and gained critical acclaim in that most sophisticated of all dance capitals. It presents the *Nutcracker* during the Christmas season, a spring series at the Opera House (fig. 59), summer performances at area theatres, and tours of the United States and abroad. Included in its repertoire are works by codirectors Michael Smuin and Lew Christensen as well as ballets by Balanchine, Ashton, and several members of its company.

The San Francisco Chamber Music Society was formed in 1960. It has fifty voting directors and a music advisory panel that selects the chamber groups that are presented by the society. It sponsors eight concerts a year, often introducing unknowns, some

of whom have later achieved prominence. In 1978 it held its first musical competition. In 1980 the competition was won by the Ridge Quartet, a very young, artistically mature group (fig. 60).

There are two main theatre districts. The downtown theatres are the Curran, the Geary, the Orpheum, the Golden Gate, the Marines' Memorial, and the Showcase, home of the One-Act Theatre Company.

The American Conservatory Theatre (A.C.T.) uses the Geary Theatre as its home for its repertory season, which runs from winter through late spring (fig. 61). The Marines' Memorial Theatre, two blocks up on Mason and Sutter streets, is used for special A.C.T. productions and touring shows. In addition, it has a training program for actors at 450 Geary Street, which also houses classrooms and small informal theatre spaces for experimental and student work. From its brilliant opening production of Molière's *Tartuffe* in January 1967, A.C.T. has built an enthusiastic following and now plays to full houses here and on tours to Hawaii, New York, Russia, and Japan.

At the Curran Theatre, next to the Geary, are presented light opera and touring Broadway musical hits in the Best of Broadway series (fig. 62). Revivals of Broadway hits are produced at the Golden Gate and the Orpheum theatres.

All around North Beach, buildings and stores have been remodeled into small theatres. The Hall of the Fugazi Social Club on Green Street is used for the Beach Blanket Babylon shows. The Spaghetti Factory and Savoy Tivoli restaurants are both owned by Freddy Kuh, who has always encouraged the use of their extra rooms for theatre, dance, and musical presentations. Los Flamencos de la Bodega, a Spanish dance and musical group that has been performing every weekend for over twenty years, and Donald Pippin's Sunday Evening Pocket Opera series became known from performances at the Spaghetti Factory. In 1979 Mr. Pippin moved his sparkling company to the Little Fox Theatre on Pacific Street, and in 1980 began performing at the On-Broadway Theatre to sold-out houses (fig. 63).

Intersection Theatre, across and up Union Street from Washington Square, hosts poetry readings, concerts of new music, modern dance, plays, and other combinations of films, art shows, and musical reviews.

Dozens of small drama, dance, and musical groups are active, some performing in remodeled stores and warehouses and others in small theatres (fig. 64). The Fort Mason complex houses solo performers, art exhibits, and several resident groups including the Magic Theatre. The Julian and Eureka

companies perform in their own theatres. There is a constant building and rebuilding of modern dance and ballet companies—some together for a single performance and others, such as the Margaret Jenkins Dance Company and San Francisco Dance Spectrum, have built solidly for years, adding tremendous variety to the dance scene. Although the Xoregos Performing Company moved to New York City in 1980, its twelve years of dance and theatre contributions are remembered (fig. 65).

San Francisco hosts all the jazz greats. Betty Carter, Oscar Peterson, Chick Corea, the Art Ensemble of Chicago, Count Basie, Cal Tjader, Philly Joe Jones, Charlie Byrd, and scores of others have appeared at the Great American Music Hall and Keystone Korner (fig. 66). Turk Murphy at Earthquake McGoon's, Pier 23's Sunday jam sessions on the waterfront, Roland's on Fillmore, for salsa, Cesar's in the Mission District, and Vince Catolica at the Fairmont Hotel are some of the San Francisco jazz attractions.

Along Montgomery Street, around Union Square, among the shoppers and strollers and at night on Geary Street and Broadway, the air may suddenly be filled with the music of street performers. It may be a jazz combo, a chamber group, a soloist playing a flute or a violin, or The Salvation Army Band (fig. 67).

A single most important act of the city fathers has stimulated the arts and has become a symbol of the city's deep involvement in the arts and the welfare of its artists. In 1960 a statute was enacted taxing all hotel room billings. In this way millions of dollars a year are distributed to art groups and museums. Over the years thousands of artists have benefited from these grants from the City Hotel Tax Fund.

Many artists have left the existing San Francisco performing-arts scene and training ground to perform in cities throughout the world. Some have become stars, some superstars.

For the residents and for the visitors, the fascinating mosaic of artistic performances, formal and forming, is a very rich part of life in San Francisco.

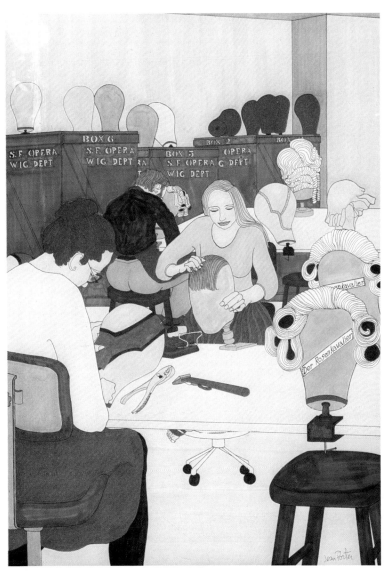

58. The Wig Department of the San Francisco Opera

59. The San Francisco Ballet at the War Memorial Opera House

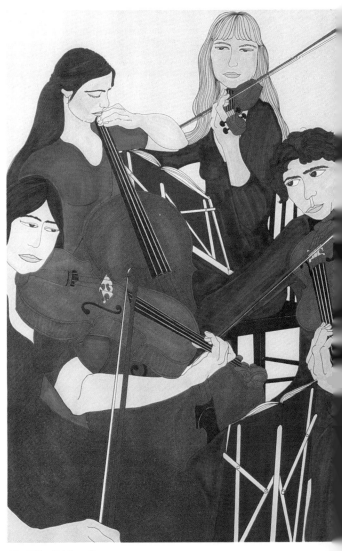

60. The Ridge Quartet

61. Geary Theatre, Home of the American Conservatory Theatre

62. The Curran Theatre at 445 Geary Street

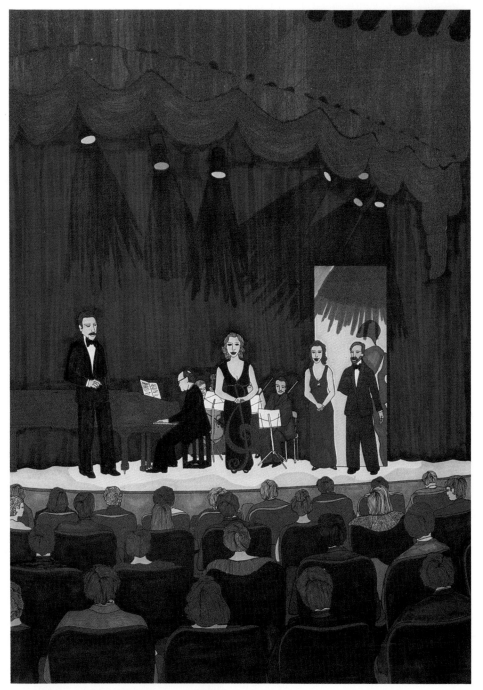

63. Donald Pippin and the Pocket Opera Company, Inc., at the On-Broadway Theatre

64. Rehearsal in the Big Studio

65. The Xoregos Performing Company—Modern Dance at
the Palace of Fine Arts Theatre

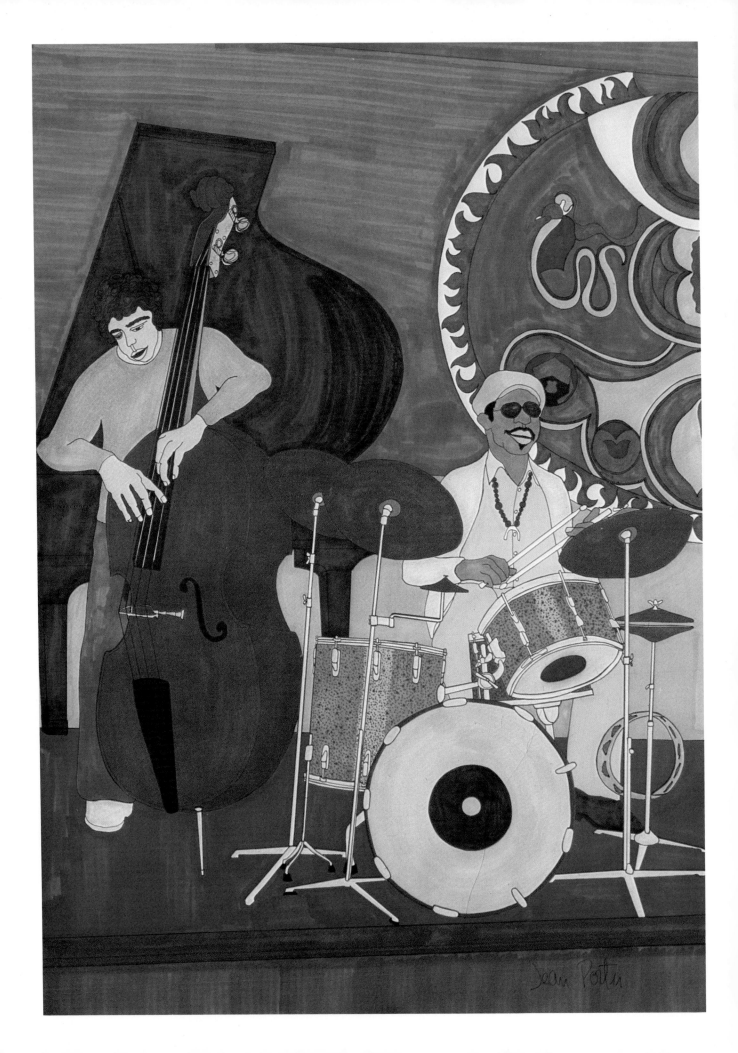

66. Jazz at the Keystone Korner—Philly Joe Jones at the Drums and Bassist Andy McKee

67. The Salvation Army Band in Front of the Bank of America World Headquarters Building on California Street

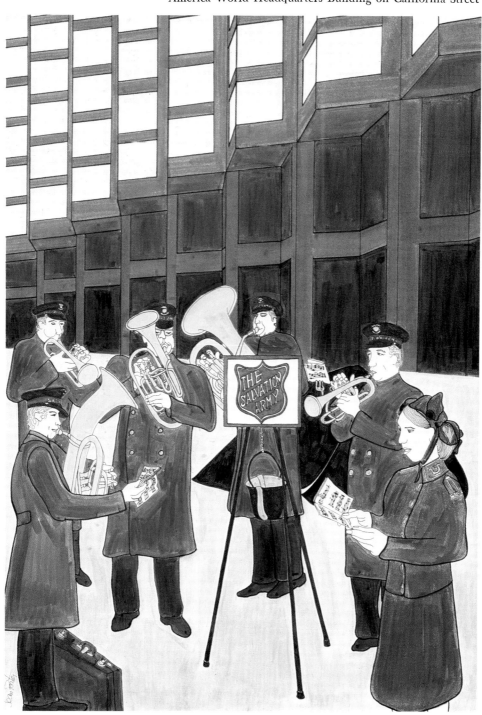

BIBLIOGRAPHY

ADAMS, BEN. *San Francisco—An Informal Guide*. 3rd rev. ed. Edited by Nora Lapin. New York: Hill & Wing, 1968.

ADAMS, GERALD. "The Neighborhoods of San Francisco," *San Francisco Examiner and Chronicle*, California Living section, January 9, 1977, pp. 2–31.

The Alta California, September 3, 1850; May 16, 24, 1949; and random issues.

ASBURY, HERBERT. *The Barbary Coast*. Garden City, N.Y.: Garden City Publishing/Knopf, 1933.

BANCROFT, HUBERT HOWE. *History of California, 1542–1890*. 7 vols. San Francisco: The History Co., 1884–1890. Reprint. Santa Barbara, Calif.: Wallace Hebberd, 1970.

BEAN, WALTON. *Boss Ruef's San Francisco*. Berkeley, Calif.: University of California Press, 1952.

BLOCK, EUGENE B. *The Immortal San Franciscans for Whom the Streets Were Named*. San Francisco: Chronicle Books, 1971.

The California Star. Yerba Buena and San Francisco. vol. 1, 1847–1848. A reproduction in facsimile of a weekly newspaper, Berkeley, Calif.: Howell-North Books, 1965.

CHINN, THOMAS W.; LAI, MARK H.; CHOY, PHILIP P., eds. *A History of the Chinese in California*. San Francisco: San Francisco Chinese Historical Society of America, 1969.

DOBIE, CHARLES CALDWELL. *San Francisco, a Pageant*. New York: Appleton-Century, 1939.

———. *San Francisco's Chinatown*. New York: Appleton-Century, 1936.

DONDERO, RAYMOND STEVENSON. *The Italian Settlements of San Francisco*. Thesis, University of California, 1950. Reprint. San Francisco: R and E Research Associates, 1974.

DOSS, MARGARET PATTERSON. *Golden Gate Park at Your Feet*. San Francisco: Presidio Press, 1978.

———. *San Francisco at Your Feet*, rev. ed. New York: Grove Press, 1974.

EBERHARD, WOLFRAM. *Chinese Festivals*. Edited by Lou Ten-Ku'Ang. Taipei, Formosa: Orient Culture Service, 1952.

Federal Writers' Project, W.P.A. *San Francisco: The Bay and Its Cities*. American Guide Series. New rev. ed. Edited by Gladys Hansen. New York: Hastings House, 1973.

FLAMM, JERRY. *Good Life in Hard Times*. San Francisco: Chronicle Books, 1978.

The Foundation for San Francisco's Architectural Heritage. *Splendid Survivors*. San Francisco: California Living/San Francisco Examiner, 1979.

GENTRY, CURT. *The Dolphin Guide*. rev. ed. Garden City, N.Y.: Doubleday & Co., 1969.

GILLIAM, HAROLD. *San Francisco Bay*. Garden City, N.Y.: Doubleday & Co., 1957.

———. *The San Francisco Experience*. Garden City, N.Y.: Doubleday & Co., 1972.

GUMINA, DEANNA PAOLI. *The Italians of San Francisco, 1850–1930*. New York: Center for Migration Studies, 1978.

HANSEN, GLADYS C. *San Francisco Almanac; San Francisco*. San Francisco: Chronicle Books, 1975.

———. *San Francisco Almanac, updated and revised*. San Rafael, Calif.: Presidio Press, 1980.

HART, JAMES D. *A Companion to California*. New York: Oxford University Press, 1978.

JONES, IDWAL. *Ark of Empire: San Francisco's Montgomery Block*. Garden City, N.Y.: Doubleday & Co., 1951.

KEMBLE, JOHN HASKELL. *San Francisco Bay*. Cornell Maritime Press. Reprint. New York: Bonanza Books/Crown, 1957.

LEWIS, OSCAR. *San Francisco: Mission to Metropolis*. Berkeley, Calif.: Howell-North Books, 1966.

———. *This Was San Francisco*. New York: David McKay, 1962.

LOCKWOOD, CHARLES. *Suddenly San Francisco*. San Francisco: California Living Books/San Francisco Examiner, 1978.

LOTCHIN, ROGER W. *San Francisco, 1846–1856*. Lincoln, Neb.: University of Nebraska Press, 1974.

MARRYAT, FRANK. *Mountains and Molehills*. 1855. Reprint. With an introduction by Robin W. Winks. Philadelphia: Western American, Lippincott, 1962.

MC GLOIN, JOHN BERNARD. *San Francisco: The Story of a City*. San Rafael, Calif.: Presidio Press, 1978.

MOORHOUSE, GEOFFREY. *San Francisco*. *Great Cities* series, by the Editors of Time-Life Books. Amsterdam: Time-Life International, 1979.

MUSCATINE, DORIS. *Old San Francisco*. New York: G. P. Putnam's, 1975.

MYRICK, DAVID F. *San Francisco's Telegraph Hill*. Berkeley, Calif.: Howell-North Books, 1972.

OLMSTED, ROGER, and WATKINS, T. H. *Here Today: San Francisco's Architectural Heritage*. San Francisco: Junior League of San Francisco/Chronicle Books, 1968. Reprint. 1978.

SALTER, CHRISTOPHER L. *San Francisco's Chinatown*. San Francisco: R & E Research Associates, 1978.

SHUMSKY, NEIL L. "San Francisco's Workingmen Respond to the Modern City." *California Historical Quarterly* (Spring 1976), pp. 46–57.

SOULÉ, FRANK; GIHON, JOHN J.; and NISBET, JAMES. *The Annals of San Francisco*. New York, 1855. Reprint. Palo Alto, Calif.: Lewis Osborne, 1966.

TODD, FRANK MORTON. *The Chamber of Commerce Handbook for San Francisco*. San Francisco: Chamber of Commerce Publicity Committee, 1914.

WATKINS, T. H., and OLMSTED, R. R. *Mirror of the Dream*. San Francisco: Scrimshaw Press, 1976.

YOUNG, JOHN P. *San Francisco: A History of the Pacific Metropolis*. 2 vols. San Francisco: S. J. Clarke, 1912.